LIMBO

Dan Fox is a writer, musician, filmmaker and editor-at-large of *frieze* magazine. His first book, *Pretentiousness: Why it Matters*, was published by Fitzcarraldo Editions in 2016. He is based in New York.

Praise for *Pretentiousness: Why it Matters*

'Dan Fox makes a very good case for a re-evaluation of the word "pretentious". The desire to be more than we are shouldn't be belittled. Meticulously researched, persuasively argued – where would we be as a culture if no-one was prepared to risk coming across as pretentious? *Absolument* nowhere, darling – that's where.'
— Jarvis Cocker

'*Pretentiousness: Why It Matters* is more than a smartly counterintuitive encomium: it's a lucid and impassioned defence of thinking, creating and, ultimately, living in a world increasingly dominated by the massed forces of social and intellectual conservatism. I totally loved the book.'
— Tom McCarthy, author of *Satin Island*

'In tackling so directly a term – "pretentiousness" – that has been thrown around too lightly for too long, Dan Fox has opened a fascinating, illuminating and barely glimpsed before perspective onto both culture and criticism. With clarity and persuasive argument he proves from an etymological basis that pretentiousness can be both good and bad – necessary even to cultural and artistic good health. This insightful book should be read like a contemporary reprise of an eighteenth-century essay on critical manners, for it shares with such texts the winning combination of wit, good sense and intellectual rigour.'
— Michael Bracewell, author of *England is Mine*

'Epoch-making, epic, historic, unforgettable, triumphant, age-old, inevitable, inexorable, and veritable. Pretentiousness will never look the same.'
— Elif Batuman, author of *The Possessed*

Fitzcarraldo Editions

LIMBO

DAN FOX

'And nothing, where I now arrive, is shining.'
— Dante Alighieri, *The Divine Comedy* (c.1320)

'To begin... To begin... How to start? I'm hungry. I should get coffee. Coffee would help me think. Maybe I should write something first, then reward myself with coffee. Coffee and a muffin. Okay, so I need to establish the themes. Maybe a banana-nut. That's a good muffin.'
— *Adaptation* (2001)

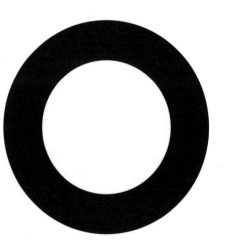

One August morning in 1986, a 25-foot shark became stuck in the attic of a terraced house in Headington, a suburb of Oxford. The fish appeared to have plunged head-first from the clouds, although there had been no reports of a freak deluge of cats, dogs and chondrichthyes the previous night. Like all sharks, it snuck up without asking first. Jammed inside the slate-tiled roof, tail cursing the sky, this new addition to Oxford's dreaming spires divided local residents. 'Ooh it makes me mad, I think it's a damn monstrosity,' said one neighbour. 'I mean, sharks don't fly, do they?' She was right. No sharknado witnesses stepped forward.

Oxford City Council tried to have the predator removed. First they cited public safety concerns, then changed tack and accused the shark of violating planning regulations. The shark refused to budge. A lengthy battle ensued. The fate of the fish was eventually placed in the hands of central government, and in 1992 the Department of the Environment, encouraged surprisingly by Conservative minister Michael Heseltine, ruled that it could stay. 'The Council is understandably concerned about precedent here,' wrote government inspector Peter Macdonald. 'The first concern is simple: proliferation with sharks (and Heaven knows what else) crashing through roofs all over the City. This fear is exaggerated. In the five years since the shark was erected, no other examples have occurred. Only very recently has there been a proposal for twin baby sharks in the Iffley Road. But any system of control must make some small place for the dynamic, the unexpected, the downright quirky. I therefore recommend that the Headington Shark be allowed to remain.'

The monster – genus *Untitled 1986* – had been built from fibreglass by local artist John Buckley. He installed

his sculpture under cover of night to mark forty-one years since the detonation of the 'Fat Man' atomic bomb over Nagasaki on 9 August 1945. For Buckley it was an oblique gesture of outrage at the existential threat of nuclear annihilation. *Untitled 1986* arrived the year Gorbachev first mentioned Glasnost. This was the era of Chernobyl, the Campaign for Nuclear Disarmament and the Greenham Common Women's Peace Camp. That spring, USAF Ravens dispatched from nearby Upper Heyford airbase had been seen in the skies over Oxfordshire on their way to bomb Tripoli. 'One question only comes to the lips: Why?' asked a puzzled BBC reporter at the scene. Bill Heine, local radio personality and the owner of the house, explained: 'The shark was to express someone feeling totally impotent and ripping a hole in their roof out of a sense of impotence and anger and desperation.' Heine, a US expat, had a reputation for rubbing Oxford residents the wrong way. As proprietor of two local independent cinemas he had previous form, commissioning large sculptures for his theatre façades: a pair of high-kicking cancan dancer legs at Not the Moulin Rouge, a few hundred metres from the shark, and, unfortunately, Al Jolson's minstrel hands over the entrance to the Penultimate Picture Palace in nearby Cowley. For one middle-aged man interviewed by the BBC about *Untitled 1986*, Heine could go sling his hook: 'I grew up in this town, and in my view the majority of people in this town are sick and tired of the publicity stunts of this crazy Canadian [sic] nutcase and if any of the Great British Public wants him on a free transfer they can have him today.'

I grew up in the nearby village of Wheatley, a few miles east of Oxford. The number 280 bus drove through Headington on its route to and from town,

passing the shark in both directions. The shark marked distance. It signalled when to think about getting up to press the request stop bell on the way into the city centre, and on Friday night's last bus home measured how much longer you'd have to spend hoping the drunks wouldn't notice you before escaping at Wheatley. I turned ten when Buckley's artwork appeared. I found it funny, and believed that more people should have giant fish installed in their roofs. Into my teens, I would pass this small-town Jaws so many times that it became un-remarkable, practically invisible. By my early twenties I was working professionally as an art critic. Snotty and of firmly held opinions, on the rare occasions I regis-tered the shark I dismissed it as a one-liner, sculptural slapstick. I thought no more of it for years.

Visiting Mum and Dad early in 2018, I took the 280 from Wheatley into Oxford. Entering Headington, a sudden impulse told me to get off and take a closer look at the shark, then walk the remaining two miles into the city. It was as though I were responding to a mysterious signal generated by the sculpture. Like the superintelli-gent monoliths in Stanley Kubrick's *2001: A Space Odyssey* – if they had resolved that the most persuasive technique for shepherding humanity to the next evolutionary level was to take to the suburbs in the form of surrealist fish. Trying my best to act casual and avoid looking like a creep, I stood outside the house staring at Buckley's work for some time. This Headington skyscraper was about to mark its thirty-second year wedged between the chimney pots, and I was fast approaching forty-two. A decade spent living in New York had defamiliarized the sight of it. Buckley's symbol of frustration became visible again. I thought of another untitled sculpture I had seen, by an artist who was curious why images and

objects lose our attention the longer we spend with them. In 2007, Simon Martin made a bronze figurine that he only considered 'activated' if a fresh organic lemon was placed next to it. If there was no lemon, or if the citrus had rotted, Martin ruled the artwork incomplete. The act of replacing the fruit every week or two was analogous to watering the plants, a reminder not to let the familiar turn invisible, neglected. In 2018, the spectre of nuclear conflict, tensions with Russia, a resurgent Right and women leading protests in the streets were back in the news. Fresh lemons for Buckley's sculpture.

What an odd sight it must have been for people seeing it in 1986 – five years before Damien Hirst turned a taxidermied shark into an artwork iconic of the 1990s, decades before pop-comical works like this became more common, the kind of spectacle you might find sitting on the Fourth Plinth in Trafalgar Square, London, or helping a New York plaza art-wash its private ownership. I was reminded of a question a student once asked me: 'When does a work of art happen?' Firstly, in the moment of its production – in the mind, then studio, then display, when its constituent parts lock into context. Secondly, when the art meets its audience and gaps, productive or otherwise, between the creative intent and its reception emerge. After that, a work of art might continue to resonate, or it can stop happening, instead drifting into aesthetic and intellectual obsolescence for years, left to gather dust on the shelf until the times change and it slips back into fashion or serious conversation again. (Stopped clocks twice a day, and all that.) If the artwork is lucky, something catches the eye of a younger generation, who blow off the cobwebs and in doing so find something altogether new to appreciate in it.

I wanted to understand why my focus on Buckley's

monster had crispened. No claims for it as Great Art came to mind. It didn't need my advocacy. The power of *Untitled 1986* was in its obduracy. A cosmic joke about political agency and death that had survived enough news cycles to start being perversely funny again as history repeated itself.

The signals I was responding to were more personal.

¶ The Headington Shark marked another milestone in addition to the distance to and from Wheatley. It got stuck on dry land almost a year to the day after my eldest brother, Karl, went to sea. Sixteen years older than me – my other brother Mark is thirteen years ahead – Karl began working on boats in the early 1980s, following a four-year stint in the Royal Navy. He saved money from jobs in the village, enough to get him down to the south of France, where he found work crewing yachts in the Mediterranean, then couriering sailboats across the Atlantic. In 1985, when I was aged nine, he joined the team of *Norsk Data GB*, one of the British entries in the Whitbread Round the World Yacht Race (now the Volvo Ocean Race). There is a photograph of me taken the day Karl sailed from Portsmouth on the first leg of the competition. After goodbyes hugged on the quayside, my family had jumped in the car to speed over to a nearby beach to watch the start of race. In the photo I'm dressed in a T-shirt and a pair of shorts, waving at the horizon. The photograph is taken from behind my back. The coast is sun-bleached in hazy white. Mainsails and spinnakers can be seen out on the water. That view of myself at one remove became my primary memory of the last time Karl was in British waters.

Our family was already accustomed to my brother being away for long stretches. In the early 1980s we would not always know where he was from month-to-month, save for the occasional postcard sent. A colourful map of Antigua and Barbuda. A whale in the Atlantic, postmarked 'Azores'. He'd telephone from somewhere in the Med, but run out of change for the payphone. 'Hey it's Karl, I'm in Spai–BEEP-BEEP-CLUNK.' We lived by the old maxim that 'no news is good news' and our parents led from experience. Tireless and supportive,

15

they encouraged Karl to see the world because they did not want him, nor any of us, to be subject to the control of institutions and social expectations as they had been. For Dad it was the Catholic priesthood he'd left to marry Mum in the mid-1970s. For Mum, the rural farming communities of Methodist North Wales. Life in small-town Oxfordshire was not for Karl.

In the Chiltern Hills, on the Buckinghamshire side of the border with Oxfordshire, is a 340-metre tall telecommunications mast. Built in the early 1960s, the Stokenchurch BT Tower is a brown concrete column crowned with antennae, satellite dishes and transmission drums. It stands eleven miles east of Wheatley, commanding an escarpment a few hundred yards off the M40 motorway that links Oxford to London. Our family nicknamed the tower 'Karl's Rocket'. Space flight, rocketry and aerodynamics were amongst my brother's enthusiasms as a teenager who was otherwise alienated by school. I listened repeatedly to Karl's souvenir seven-inch record of the first lunar landing, and as a pre-teen science fiction fan, I found enjoyment imagining the spaceways. Karl's Rocket worked to explain his absence. It stood for elsewhere, a relay-station transponding messages to and from the Headington Shark. The Earth orbits the Sun at a distance that astronomers nickname the 'Goldilocks Zone' – neither too hot nor too cold. I have wondered if this is Karl's preferred range of orbit from home; far enough to know what deep space held, yet still warmed by family care and concern. I pictured Karl inside the nest of antennae, piloting it to distant planets and sending us reports from the Goldilocks Zone. I considered the sea to be his domain but for a child in landlocked Oxfordshire it might as well have been outer space.

¶ The month the Headington Shark flagged me off the bus I was meant to be writing this book. And this book was meant to be another book. (Don't all writing projects career off course and digress themselves towards new destinations? Possible exceptions: car user manuals, medical texts, protocol for deploying nuclear missiles. Best to stay on topic in those genres.) Originally, this was intended to be a collection of travel essays designed to shed collective light on Important Topics to be divined later. Touring China with my band, six weeks on a container ship sailing from the Thames Estuary to Shanghai, visiting a commune in northern California, and a clutch of other postcards. The book even had a working title, but I had made the mistake of naming the baby before looking into its eyes. A Lisa better suited to Luisa. A Benny who should've been a Lenny. Writing began, and it soon became clear that I was unable to add new territory to the literature of travel other than gravel for landfill. Then came a lurch of personal crises. Significant derailments, but too commonplace to warrant slinging ink at. The urgency of recounting my travels shrank to a tiny amplitude.

Writing limped. Writing crawled. Writing stopped. Words became gummed-up and gear-seized. For a period, text messaging a close friend in Los Angeles and an exchange of postcards with a writer who lived half-a-mile away amounted to the only writing I produced. If only I could write myself out of my funk, like Anthony Trollope, who claimed to start each day at 5.30 a.m. and write 250 words every fifteen minutes, for three hours. I was too old for the live-fast methodology of Robert Louis Stevenson, who wrote 60,000 words of *The Strange Case of Dr Jekyll & Mr Hyde* in a six-day cocaine binge. Eventually I decided to cannibalize

the travel book for small parts and abandon the rest to rust at the side of the road.

Gene Fowler – journalist, screenwriter and prolific at both – said 'Writing is easy. All you do is stare at a blank sheet of paper until drops of blood form on your forehead.' Between days spent hoping the head wounds might open, but too squeamish to accelerate the process through self-trepanation, I started playing the piano. I practiced scales, and revisited pieces of music I'd learned as a teenager. A simple Claude Debussy composition, two or three old Bowie hits. I tried massacring a couple of numbers from a Kurt Weill songbook, but stopped before the ghost of Lotte Lenya could take revenge and took up painting instead. I'd done little since leaving art school in '98. My chops were rusty, and I kept the daubs behind doors, a strictly private activity. Painting offered oxygen when the 1:1-scale reproduction of words from mind to page was suffocating. It encouraged chance operations between the hand and eye. Sweet relief. I made images of plant foliage and rough portraits from iPhone photographs. The disconsolate mind finds comfort in odd-shaped corners.

I felt adrift. But wasn't 'blocked' the term for this paralysis? 'The term itself is grandiose,' Joan Acocella tells us, 'with its implication that writers contain within them great wells of creativity to which their access is merely impeded.' Geoff Dyer calls writer's block a lazy cliché, lavatorial even. He prefers the term 'writer's dread'. 'Now there's a subject for an essay – if one could face writing it.' I thought of Everett, the protagonist in Jonathan Lethem's novel *Amnesia Moon*, who travels across a post-apocalypse America in which nobody can agree on how the eschatological catastrophe has played out. Lawless towns terrorized by petrolhead warlords.

18

A landscape covered in dense green fog. A community governed by luck. Take your pick. I felt I was in No-Man's Land, the Twilight Zone, the Upside Down, the wasteland, the badlands and the boonies. On the sidelines, on the bench, on hold, on standby, out-of-sync, in the wings, up the creek, in a ditch, in a fix, in a funk, in stasis, in suspended animation. Muddled and moribund, mudbound in muddy waters. Clogged, congested, confounded, choked-off, jammed, stumped, stonewalled and stymied. Flummoxed, bamboozled and blocked. Frog in the throat. Bone in the gullet. Crashed into a wall. Also: dithering, floating, unanchored, unmoored, untethered, blown on the breeze. Caught between a rocky trope and a hard cliché. Stuck in limbo.

¶ I imagine limbo as an extraterritoriality without walls, without corners, windows, entrances or exits. I can also cast it as ocean and desert wilderness. Or a blind-black void that has swallowed all light and matter and threatens a sublime death. "Tis a strange place, this Limbo!' Samuel Taylor Coleridge imagines 'Time and weary Space / Fettered from flight, with nightmare sense of fleeing / Strive for their last crepuscular half-being.' (As Ridley Scott's *Alien* warned audiences: 'In space no one can hear you scream.') Limbo might bring to mind a zone of white nothingness. A space of minimalist perfection that looks like a giant infinity curve or the interior of a contemporary art museum. In his essay 'Inside the White Cube', the artist and critic Brian O'Doherty describes the effects of the 'unshadowed, white, clean, artificial' spaces of the art gallery, in which art 'exists in a kind of eternity of display, and though there is lots of "period" (late modern), there is no time. This eternity gives the gallery a limbo-like status: one has to have died already to be there.' Limbo is at the apex of visual sophistication: an extra-dimensional loft done out in luxury-plain Jil Sander grey. Empty and placid, with not even a reproduction Eames chair to interrupt the anodyne tastefulness. No mess, no colour, no life. No hint of recidivist ornament – Adolf Loos would have loved limbo. In Harold Pinter's words, a 'No man's land, which never moves, which never changes, which never grows older, which remains forever icy and silent.' (And full of dread: 'Nomaneslond' was the fourteenth-century name for execution sites to the north of London's city walls.) No day, no night, no seasons. 'Lank space,' Coleridge called it. Or is it? By definition it stands for an in-between space. Limbo appears at the edge of daybreak and at dusk. It's a cusp word used for

conversations held in the golden hour.

Limbo: that corporeal first consonant, the symbolic, annular nothing at the end of its second, the deliciously dumb sound that both sing together. How do you define a secular nothing into which you can drop anything? This green zone's permutations are many. For comics fans, Comic Book Limbo is where old or unwanted characters are dumped by their publisher, DC: Animal Man, Merryman, Ace the Bat-Hound, The Gay Ghost. In the final instalment of The Wachowski Sisters' *Matrix* trilogy, limbo is anagrammatized into Mobil Avenue subway station, and in Christopher Nolan's action flick *Inception*, it's the name of an 'unreconstructed dreamspace' into which a pair of lovers retreat. The titular free spirit in Andre Breton's 1928 surrealist novel, *Nadja*, announces: 'I am the soul in limbo.' When she is committed to the Vaucluse sanitorium, the narrator observes: 'The essential thing is that I do not suppose there can be much difference for Nadja between the inside of a sanitarium and the outside.' *The Man From Limbo* is a novel written in 1930 by Hollywood screenwriter Guy Endore, later blacklisted as a Communist; limbo is the poverty from which the book's hero tries to escape, and where Endore later found his career had slipped. *The Man From Limbo* is also the title of a 1950s noir detective story by John D. MacDonald in which a damaged army veteran on his uppers, coerced by his shrink to become a salesman, gets caught up in a political corruption scandal – limbo is where the anti-hero's war trauma has consigned his dignity.

For the Danish game developers Playdead, *Limbo* is a quiet, puzzle-solving videogame about loss. In Hirokazu Kore-eda's 1998 film *After Life*, a drab administrative centre-cum-film studio processes dead

22

souls on their way to heaven. Here, social workers help the souls identify their happiest memory. The dead wait patiently in limbo as this memory is recreated for them to experience for the rest of eternity. The subtitle to John Wallace Spencer's *Limbo of the Lost*, written in 1969, promises 'Actual Stories of Sea Mysteries'. Limbo District was the name of a a short-lived but influential band in Athens, Georgia, during the 1990s. I am told that in Marseille there is a neighbourhood bar with a sign in the window which declares: 'Bienvenue dans les limbes.' For the Long Trail Brewing Company in the US state of Vermont, Limbo is the name of an India pale ale. On the bottle's label a skeleton sits beneath a blood-red tree, bringing to mind the one about the skeleton who walks into a bar and orders a pint of lager and a mop.

¶ One technical issue with being 'in limbo' is that they abolished it in 2007. Said they were doing so for the sake of the kids. As 'they' were the Catholic Church, the kids could tell you this was no guarantee of anything. Limbo had been struck from the Catholic catechism in 1997, but the concept had not been officially dismantled. Following a three-year consultation authorized in 2004 by Pope Benedict XVI the church finally nailed up the shutters and boards with a 41-page report from the Vatican's International Theological Commission, snappy title: 'The Hope of Salvation for Infants Who Die Without Being Baptized'.

Like any religion, the Roman church likes to think of itself as eternity's One True Department of Planning. But theirs are not the afterlife's only theological zoning laws. Zoroastrians teach the existence of *hamistagan*, a holding pen for souls whose good and bad deeds are of equal weight, and Tibetan Buddhists believe in the *bardo*, a transitional state between death and reincarnation. In Islam, there is *barzakh* (from the Persian for 'barrier,' or 'partition'), an interstitial period spent between death and *Bihar al-Anwar*, the Day of Judgement. According to the scholar Meir Lubetski, the word 'lmn', in its earliest usages in the Mediterranean cultures of the Bronze Age, meant a point where land and sea met, or a harbour. In Latin the word *limbus,* meaning 'hem' or 'border', first described the edges of the Roman Empire. The word evolved to mean spaces of transition and in-betweenness. In today's secular usage, it refers most commonly to an interstitial period of uncertainty awaiting a decision. In that sense another way to describe mystery. Blind-spot geographies: The Bermuda Triangle, Area 51. Limbo can be the paralysis brought about by seeing life's antagonisms from multiple perspectives. It is also

24

a way station for the exile. Worse, a state of abandonment. The word stretches from existential captivity to real states of incarceration. Limbo is border country in which to wait in uncertainty for something, or rot in certainty for nothing.

The closure of limbo's R.C.C. branch made no discernible changes to earthly affairs. Pope Benedict's removal of limbo from the pan-dimensional hereafter in 2007 did not result in long queues at the Post Office melting away, or an end to hours delayed in airports trying to find comfort on seats designed by people who understood 'ergonomics' to be spelled 'p-u-r-g-a-t-o-r-y'. To this day, buses still do not turn up on time when the weather is bad and you're late for work. The automated message 'We are currently experiencing a high volume of calls' continues to cast us as heroes in our own personal Franz Kafka adventure. (I wonder what hold music they played in limbo? A lone, unchanging drone. A perpetual bridge that never reaches its chorus. A lock-groove loop of *Windmills of Your Mind*: 'Round like a circle in a spiral, like a wheel within a wheel / Never ending or beginning on an ever spinning reel...') Decisions pending about relationships, job applications, school exams, plebiscites, credit card applications, overdraft extensions, medical tests, government inquiries, insurance claims, buying a house, coming out, having children, getting married, getting divorced, gender reassignments, court hearings, parole hearings, euthanasia cases, autopsies and death sentences all still pend.

When Pope Benedict's Catholic theologians began grappling with their faith and metaphysics, Mehran Karimi Nasseri was entering his fifteenth consecutive year living in Terminal 1, Charles de Gaulle airport, trapped without papers and no way of entering France

nor returning to Iran, his country of origin. (He was finally admitted to an uncertain future in Paris in 2007, just months after limbo's abolition. Perhaps the Vatican was onto something.) In 2013, the intelligence whistleblower Edward Snowden spent forty days waiting at Moscow's Sheremetyevo Airport whilst on the run from US authorities. The disappearance of limbo did not enable Constantin Reliu to escape from legal abeyance either. The 63-year-old returned home to Romania after 20 years living in Turkey to find he had been officially declared dead, despite turning up to a court hearing to dispute his own death certificate in March 2018.

Millions of asylum seekers, refugees, immigrants and stateless people remain stuck without countries to provide them with membership of a political community – the citizenship and passport that would afford them what Hannah Arendt called 'the right to have rights.' Refugee boats roam the Mediterranean, refused harbour in port after port. Families are torn apart at the US frontier, and the children are put in cages then lost into social services facilities across the country. They continue to wonder if they will ever be reunited. Limbo, weaponized.

'Cultural identity is not fixed, it is a moving feast,' said Stuart Hall, who saw history and origin as an 'unfinished conversation', but try inviting the strong-arm nativist to that meal. The aggressive and aggrieved who try to push the world to the political right blame many problems on those who cross national borders in search of a different life. Populists fixate on fixing borders because they provide ways to control the bodies they fear (due to ethnicity, sex, gender, class) and the bodies they crave (those similar to their own, or most easily exploitable for political gain). No matter how far across the

world you move, the one place from which you can never escape is your own flesh and blood. Knees that crack, feet that ache, a belly that needs feeding, a mouth and tongue trained to form words in a certain way, speech patterns that give away your origins, sicknesses that warn you of a toxifying world. Your brain is always housed in that same place, regardless of where your online presence may be broadcast. Limbs and organs can move from continent to continent, accompanied by whatever phone, laptop or other internet portal made from plastic and metal keeps you logged into your digital life, but those body parts can never take a holiday from each other. (Even an arm or a leg that has been lost can still persist in the cognitive wheelhouse of the amputee as a functioning part of the body – a phantom limb.) Many bodies cannot travel without abuse, hassles, refusals, restrictions nor the assumption that all bodies can walk up stairs and have the strength to push open doors and the eyesight to read signs.

Common phrases used to describe belonging, to signify some form of home, are spatial: 'fitting in', say, or 'being in a good place' emotionally. Few would say they enjoy 'being a round peg in a square hole'. We might correlate these ideas with musical images of being 'in unison', 'in harmony', 'in accord,' 'attuned' – that is, living and working with people who are of similar mind. It's language rooted in having bodies that need physical places to comfortably inhabit, amongst neighbours who will include rather than exclude us. The liminal area of one thing, by definition, has to meet the edge of something else even if that's thin air. Limbo suspends bodies and minds in-between. Such as Stephanie, who, as The Velvet Underground sang, was stuck 'between worlds', and wanted to know 'why it is though she's the door, she

can't be the room'.

Lines that traditionally demarcate gender and sexuality wobble, break and reconstitute themselves in new forms. In the arts, to 'break boundaries' is virtuous to the point of cliché. Some rejoice at this whilst others entrench in fear. New, stronger partitions are called for by those scared of change and what they do not wish to understand. Paradoxically, similar entrenchments play out amongst those who would ostensibly wish for all borderlands to disappear. 'Oppositional politics are often shaped by the very thing they oppose,' writes Paul Clinton. 'Accusations flung at "cis white men" reinforce the kinds of essentialism that those who believe in gender fluidity would seek to escape.'

 Power to define the centre is power to define the edges. Groups who do not find acceptance in the middle are pushed out on a limb. Mistrust dogs those who dare to go 'too far', who are seen to violate inner boundaries in pursuit of spiritual or therapeutic self-knowledge (with, for instance, mind-altering drugs), or outer ones in the name of science – think of Dr Frankenstein's tragic Promethean experiment. Yet for some, a life at the margins is a matter of principle. Those who live dangerously, taunting death by courting misadventure through drugs or the adrenaline highs of extreme sports. The post-war figure of the artist whose integrity hinges on a refusal to sell out to the mainstream. But in hinterland new centres are built: the adoptive family or radical commune, say, who have rejected conventional structures of community in search of different models of kinship. Given time, the centre will expand and eventually swallow the edgelands. What to one generation's eyes seems too extreme – too fringe or avant-garde – will with slow, tectonic inevitability, become accepted

28

into the canon, forming mainstream attitude, or even paragon conservatism. Carefully performed attitudinal indifference – hanging back from the centre, playing it cool at the edge of the room – can congeal into inertia and cynicism. In the most extreme cases it can stop a person from doing anything for fear of losing their cool – stasis anxiety. Now the value of 'cool' is monetized and recoded, used by the wealthy and privileged to police social boundaries between themselves and those they consider beneath them. And so we find ourselves back in an extra-dimensional loft done out in lifeless luxury-minimal Jil Sander grey.

¶ For medieval Catholic theologians, limbo – often conflated with purgatory, an overheated waiting room processing souls with chequered pasts – was a place for the church to dump bodies that did not carry the correct paperwork. (In a letter written to his fictional friend Malcolm, C. S. Lewis described purgatory as an astringent mouthwash to be drunk after 'the tooth of life is drawn and I am "coming round."') The name applied to two zones: *limbus patrum* (Limbo of the Fathers), and *limbus infantum* (Limbo of Infants). Limbo of the Fathers existed on the fringes of Hell and was a place reserved for men who had died before Jesus Christ lived. Where the old prophets waited in unfinished happiness was a restricted ward, but not a penal confinement. In his fifteenth-century painting *Christ in Limbo* Fra Angelico depicted limbo as a dark and cool cave. A simple, classical arch has been carved at its mouth, as if the entrance to a secret system of passages drilled deep inside a mountain. A century later, a follower of Hieronymous Bosch dumped limbo on the bank of the River Styx, beneath an acrid smoke-filled sky – souls huddled together beneath the entrance to a light-filled tunnel where Christ is to rescue them. In the fourth canto of his *Inferno*, Dante Alighieri – writing in exile from his home town of Florence – describes limbo as a twilight grove where those who were without sin but who had 'lived before the Christian age' waited patiently until Christ descended to the underworld for the Harrowing of Hell, liberating them to enter Heaven. 'Here in the dark (where only hearing told),' writes Dante, 'there were no tears, no weeping, only sighs / that caused a trembling in the eternal air – / sighs drawn from sorrowing, although no pain.' Gustave Doré, illustrating *The Divine Comedy* in the 1860s, stayed close to Dante's vision, depicting

limbo as woodland frozen in crisp, monochrome moon-light. Dante's guide, Virgil, points out Old Testament saints: Abel, Noah, Abraham, David, Rachel. Walking amongst the trees they see the pagans Homer, Horace, Ovid and Lucan, amongst others. On a 'verdant lawn' Dante and Virgil meet the Greeks – Socrates, Plato, Euclid, Hippocrates, Zeno – the Muslim philosophers Avicenna and Averroës, and a contemporary figure, the warrior-sultan Saladin, widely admired by the Crusader armies who fought him.

Limbus infantum offered no route out. Here were the souls of children who had died before receiving abso-lution from Original Sin through baptism but were considered too young to be capable of committing per-sonal sins. (Provision in *limbus infantum* was also given to those suffering from mental illness.) St Augustine held that limbo would make these infants aware of their privation from God. Thomas Aquinas rejected Augustine's assessment. Innocent, but with no knowl-edge of God's grace nor the possibility of salvation, Aquinas argued that these children would look forward to an eternal state of joy in limbo, not a cosmic work-house, for they could not miss what they did not know existed. Ignorance was bliss in The Great Big Creche in the Sky. When William Blake painted 'Homer and the Ancient Poets', he gathered the Greek delegation to *limbus patrum* under low-hanging boughs, quietly com-paring verse as they wait for Christ to bring them to Heaven's wicket. But threading the ice-blues and sil-ver clouds above them are women clutching unbaptized children condemned to *limbus infantum*. The juxtaposi-tion is pointed; Blake did not believe in eternal torments.

Booming populations and the spread of secular-ism were pressing reasons for the twenty-first century

Roman Catholic Church to close shop on limbo. 'The number of non-baptized infants has grown considerably, and therefore the reflection on the possibility of salvation for these infants has become urgent,' stated the 2007 Vatican report. Limbo represented an 'unduly restrictive view of salvation', as 'people find it increasingly difficult to accept that God is just and merciful if he excludes infants, who have no personal sins, from eternal happiness, whether they are Christian or non-Christian.' It was also hard not to read the decision as a backhanded way for the church to address its vile legacy of sexual abuse. Doctrinal pieties meaningless to the victims of predatory clergy. In all this handwringing echoed John Milton's satire of bells-and-smells Catholicism in Book III of *Paradise Lost*, where papal favours and punishments are consigned to a limbo he calls 'The Paradise of Fools':

> Cowles, Hoods and Habits with thir wearers tost
> And flutterd into Raggs, then Reliques, Beads,
> Indulgences, Dispenses, Pardons, Bulls,
> The sport of Winds: all these upwhirld aloft
> Fly o're the backside of the World farr off
> Into a Limbo large and broad, since calld
> The Paradise of Fools.

When the Vatican published its report, Father Paul McPartlan, a British member of the commission, hedged his bets. 'We cannot say we know with certainty what will happen to unbaptized children but we have good grounds to hope that God in his mercy and love looks after these children and brings them to salvation.' Limbo in limbo.

¶ The Headington Shark made the most of its circumstances. Its head was positioned beneath the level of the rooftiles, giving only Heine the privilege of one-on-ones with the beast. The shark had to rely on body language to communicate with the public. Unable to see 280 buses and unaware of older brothers out at sea, indifferent to Oxford's ivy-clad gothic architecture, it ate planning violation notices for breakfast. Stuck inland, the shark started conversations about art and meaning. It provoked arguments about whether one person had the right to make personal political statements by changing the shared landscape, and threw into relief the aesthetic anxieties of heritage-minded Oxford. The shark was not going anywhere and so it tried to make its intransigence productive.

Buckley and Heine had glued together two things that rarely shared company: a house and a shark. (An old creative trick bringing to mind the Comte de Lautréamont's line about 'the chance encounter of a sewing machine and an umbrella on an operating table', which always struck me as less of a surrealist dream image than a Post-It note reminder to stay open-minded.) This collision of meaning – aside from the grating flamboyance of it – upset the public. A house should be fixed in one place and ideally represent the stability of home. Sharks keep moving and they eat people. Buckley's sculpture disturbed an idea of domestic stability, but also represented a living thing stripped of its agency to roam and live where it wants.

The shark contradicted a cliché we are told about life, that it is a 'journey'. That your project is progress. What was once a religious metaphor has turned managerial, better suited to a capitalist model of life that demands perpetual motion. Go forward. Hit the ground running

*note to self - start at five

with actionables and deliverables. Grow through teach-able moments. But why? The fallow field is as necessary to the farmer as the the one filled with crops. For an artist, an unforeseen accident that stops them working, such as a studio fire, might clear the psychological brush and leave ashes that provide nutrients for the soil. Patience brings the unexpected: 'I wait not for time to finish my work,' wrote the artist Ray Johnson, 'but for time to indicate something one would not have expected to occur.' The English language has many declensions for immobility, physical obstruction, in-tellectual indolence, or emotional paralysis. Ways of feeling stuck. Old High German and Old English give us *stician*, meaning 'to pierce, transfix, stab or goad', like an insect pinned to an entomologist's display board. A 'stick-in-the-mud' resists change. A person who is 'unstuck' has lost the plot. (The one who has become 'unhinged' – taken the door off its frame – has removed an obstacle in their path, but triggered a different state of consciousness or mental illness.) The nostalgist or trauma sufferer is 'stuck in the past'. Billy Pilgrim, hero of Kurt Vonnegut's *Slaughterhouse Five*, was 'unstuck in time' by PTSD. If you're 'stuck-up' you think you're better than everyone else, and insecure of showing – note echoes of 'stick' – the stigmas of class. (See also: *stigmata*, the mark of Christ's crucifixion wounds on the hands, feet and heart. You've deluded yourself up to a new level of holy class snobbery if you claim you bleed like Jesus.) Get stuck in a dead-end job and get the cor-porate deathburger stuck in your windpipe. You can whine and sound like a stuck record. Find yourself stuck in the middle, stuck in a relationship, stuck in jail, stuck in traffic, stuck on the sidelines, stuck in transit, stuck for words.

34

Flip the stick, however, and I'm stuck on you. The word also moonlights on behalf of solidarity, companionship and support. Let's stick together – and by the same token, let's exclude others. Adhesion, fixity, reliability – stick with it and you'll be rewarded. Get stuck in and help yourself. The stuck record repeats, but repetition is a powerful musical device: incantatory, hypnotic, ritualistic. Mark E. Smith of The Fall declared that 'The three Rs are: repetition, repetition, repetition.' Repetition is reassuring, because it suggests there is a pattern to the universe we might be able to grasp, and refine our responses to. (In the film *Groundhog Day*, Bill Murray's TV weatherman, Phil, asks his B&B landlady: 'Do you ever have déjà vu, Mrs Lancaster?' Mrs Lancaster: 'I don't think so, but I could check with the kitchen.') Also: 'R' for resistance and the virtuous digging of heels into mud. And here we come to block; not that suffered by writers, but the deliberate construction of impasse. A carefully timed deflection. It is disobedience and resistance, a micropolitical strategy, as Emily Apter explains in *Unexceptional Politics*, 'on both the right and the left, of insolence, impertinence, discourtesy, truculence, tactlessness and intractability.' It is the mantra of Herman Melville's *Bartleby the Scrivener*, who 'would prefer not to'. Sit-ins, occupations, traffic stoppages, strikes and boycotts generate energy through obstruction, just as a hydroelectric dam blocks water to create power.

Care is needed. Something stuck is something fixed, resistant, even reliable. Liquidity and flow are amongst its antonyms, concepts we might positively associate with inspiration, creative productivity, good business. But 1930s fascists used the language of fluidity to misogynistic effect, contrasting women's bodies with the supposedly solid ideal fascist male. In his book *Male*

35

Fantasies, Klaus Theweleit describes the ways in which liquidity was considered a weakness; it carried disease, dirt, and other unmentionable, unmanageable forms. Fascists used words such as 'flood' and 'rain' to fearmonger about large numbers of undesirable bodies crossing borders and polluting the homeland.

In the early part of this century, battalions of US Navy SEALs learn to induce altered states of consciousness in order to run operations as a hive mind. At their HQ in Norfolk, Virginia, SEALs train in the 'Mind Gym', which includes sensory deprivation tanks used to focus specific brainwaves and physiological functions. Here the military attempt to harness the power of the subconscious mind so that their fighters can, according to their Commander Rich Davis, accelerate learning curves, 'flip the switch' and 'merge with their team'. Researchers study mindfulness, and visit the desert Burning Man festival in order to harness 'communal vocational ecstasy' on behalf of tech firms such as Google. They are in search of the 'optimal experience' — what psychologist Mihaly Csikszentmihalyi terms the 'flow state'. These are the kinds of people who might use phrases such as 'life hack' and consider themselves 'disruptors'. And in those contemporary states of flow and hive mind missions might be spotted traces of 'the toxic holism of the fascist "we,"' as Elizabeth Schambelan puts it, 'achieving mind meld with his comrades.'

¶ I haven't attempted a proper audit of time spent in Karl's company during my life. Less than a decade, at a guess. But I know the stories. Karl's Rocket delivered intermittent messages to the family television. During the '85 Whitbread Race, each team was given a video and stills camera to document their experiences. The photographic material was couriered to a production company at the end of each leg, who would edit the material for broadcast on the ITN News in the UK. I would get special dispensation to stay up late, and we would sit together waiting to glimpse a shot of Karl fix rigging in a squall, or helming the ship in high winds. In one dispatch he is filmed in the cramped galley, fresh off watch and with carefully controlled anger describing the circumstances that have led to a crew member nearly being lost overboard. 'I was gonna start this post-mortem by saying that it was only a matter of time until this watch lost either a life or the mast.' Another shot crops close to his face, tight enough to see sail canvas and ocean reflected in his shades. The weather is bright and clear. His broad, handsome face is set with concentration. For Karl at this second, life has no end point. For our family watching it weeks later, we simply know he is alive.

Over the years he has given us snapshots. Shark fishing. Mutinees. Making bodywork for racing cars. Learning to read Polynesian sea maps made from shells and twine. His friendship with Tracy Edwards, skipper of the all-women Whitbread entry *Maiden* – motto: 'Lock Up Your Sons!' Work in composite materials engineering. His study of the Hawaiian *hula* tradition. Working boats for Middle Eastern royals. Celestial navigation.

For his first ocean crossing my brother took a boat from Spain to Antigua on behalf of a man named

Poodle. The ship was crewed by Karl, his friend Pete, and Brian, their captain. They got lost. 'We didn't trust Brian's navigation. I had an FM radio which contains a carbon bar running the length of the radio and always gets the best reception when it is perpendicular to the source of transmission. We could ascertain Guadeloupe was over there, Saint Martin here, Antigua there, just by moving the radio from side to side.' They ran out of drinking water. 'Our tank had sprung a leak – luckily the day after we finally ran clean out of water it poured with rain and we were able to collect just enough from the sails to get us through.' Food became scarce. 'Brian hadn't provisioned himself properly. We started having to share our food with him, which created resentment.' They almost pushed their captain overboard.

'He was crazy. It got pretty ugly on board. He had a bad habit of shitting, nude, over the side of the boat, in front of you. One morning the back end of the boat swung and the jib came across and knocked Brian clean over the side, hanging by the guard rail with all this crap up his legs. We sat in the cockpit laughing. Pete and I looked at each other and thought: you know what, a quick crack on the knuckles of each hand – he'd be gone. We discussed it in hearing range of Brian. It was only half-heartedly meant but there was five minutes when we considered it. In the end we threatened him with a winch handle, told him to change his behaviour. Then we pulled him back on board. We had a pretty good relationship with Brian for the rest of the journey.'

Being stuck for words is familiar to me for reasons other than the writer's trade. During my childhood, each telephone call from Karl would send me on a direct route from joy at the sound of his voice to tears when we had to hang up. That circuit wired itself in place.

In adulthood a switch still flips when a sign-off or hug goodbye comes into view. I fall into a zone located between my adult eyes and the back of the boy on the beach in the photograph taken the day the Whitbread Race began in 1985. Words grind to a halt in my throat. The language ducts flood, and I am unable to speak.

The nine-year-old who stood on the beach waving Karl off to sea in 1985 idolized him. But I was too young to understand why he would never come home. The child dreams up implausible causes for adult actions. Perhaps, deep down I believed his leaving was my fault, and that, unawares, I had done something to drive him away. It was nobody's fault. Our family home was a loving, secure environment yet Wheatley and its small-town mentalities were not. Mark had followed Karl out as soon as he was able. Karl, from a distance, taught me how to travel, Mark – who first trained as a nurse, before becoming a designer – showed me ways to live once I too had left, a role model of a different kind. I accepted Karl's absence but I could never quite explain to myself the persistence of difficult goodbyes. Occasionally in adult life I have experienced embarrassment at this tearful aphasia every time I leave Karl. The sense that I should have grown out of it, as if a powerful childhood experience is the same as a pair of old shoes. There is no earthly reason why I should feel embarrassment: I miss my brother and I hate goodbyes. No need to 'man up,' or 'act like a man', or some other axiom of toxic masculinity that no member of our family would ever advise following – least of all Karl, for all his stories of mutiny on the waves.

¶ Professionally speaking – if skulking outside the shark house that day in 2018 was professional – I sympathized with the Headington monster's predicament. Like all but the most confidence-thick writers – never trust an artist who does not possess self-doubt – I understood what it felt like to be in public, tail in the air for everyone to see, point at and file planning complaints against. I knew the bricked-in vexations of writer's block. Disillusionment with the visual art industry in which I then worked a full-time job weighed heavy, and I could not chart course into clearer waters. (The word 'acedia' describes a form of spiritual stagnancy found in ascetics and priests who have served the same parish for too long.) 'He knew not what to do,' wrote Coleridge '– something, he felt, must be done – he rose, drew his writing desk suddenly before him – and found he knew not what to do.' I needed whatever potion the carefree Karl was drinking in the '80s.

Feeling stuck can stem from a fear of embarrassment. Fear of the censure of others for 'trying too hard', for being pretentious, for being blind to one's own positionality. Fear of not getting it, of having missed the class in which 'the right references' were handed out. Fear of not having any 'right' in the first place. Anne Lamott imagines an invisible panel of observers, super-egos wearing 'impress me' faces poised ready to trip the writer up: 'First there's the vinegar-lipped Reader Lady, who says primly, "Well, *that's* not very interesting, is it?" And there's the emaciated German male who writes these Orwellian memos detailing your thought crimes. And there are your parents, agonizing over your lack of loyalty and discretion; and there's William Burroughs, dozing off or shooting up because he finds you as bold and articulate as a house plant.' On my judges' bench sits a dour

circa
2019 ✕

42

art theorist who disapproves of the first person for being crypto-capitalist and insufficiently rigorous. A gossip of New York world-wearies roll their eyes for want of something more novel, and a literary over-achiever who politely asks questions such as 'are you still writing?' in the hope that I am not. These policemen in the head embellish the daily writing cycle with their commentary as it turns through cautious optimism, then enthusiasm, to cold fronts of self-doubt, loss of faith, plans to give up and get a new job, and back to cautious optimism again.

Wayne Koestenbaum observes how humiliation, 'involves the classic trio of social markers: gender, race, class. Humiliation depends on what you look like, what you sound like, how much money you make, how you walk, how you smell, where you put your garbage. Humiliation hits us where we live, on the confusing, inexorably determining grid of blackness, whiteness, maleness, femaleness, in-betweenness. If we dwell in limbo, in transition, that homeless location, too, is humiliating.' Those social conditions – the external pressures wrought by class, gender, race, sexuality – have corrosive effects. They strip a person's ability to speak by denying access to education and resources, and inhibit the right to speech. And even if you are in command of language, it may not be in a form respected by those in positions of social privilege, and you will be mocked for attempting to use it the 'wrong way'.

These environmental conditions create 'silences', as Tillie Olsen called them; silences of 'work aborted, deferred, denied', censorship, political circumstances, marginalization, and 'silences where the lives never come to writing' for whatever unfortunate reason. If Shakespeare had a sister who tried to become a writer, Virginia Woolf argued in *A Room of One's Own*, she

would have 'ended her days in some lonely cottage outside a village, half witch, half wizard, feared and mocked at'. The effort of fighting these conditions is exhausting. 'I think I've only spent about ten per cent of my energies on writing,' noted American journalist Katherine Anne Porter. 'The other ninety per cent went to keeping my head above water.'

'Embarrass' derives from the French *embarrasser*, meaning 'to block'. One archaic usage is even nautical: in the 1867 W. H. Smyth *Sailor's Word Book*, embarrass is 'an American term for places where the navigation of rivers ... is rendered difficult by the accumulation of driftwood.' We tie it to shame: to make a person feel awkward through your own speech or actions, or to feel ashamed when your own language or body fails in a way that alienates you from others. Feelings best kept hidden in the wings, forced onstage without knowing what actors would call the correct 'blocking'. (This theatrical term comes from the pieces of wood that Gilbert & Sullivan used to work out where performers should position themselves.) Embarrassment makes you the butt of a joke, but it can also unclothe a complicated social truth.

Shame shapes identity long-term. Embarrassment is only a temporary 'failure in self-presentation', as Christopher Ricks has it. It needs a performer and an audience to witness it as a violation of social protocol – sometimes revealing the absurdity of that convention in the first place, especially if the violator doesn't see their actions as embarrassing, but rather regards them as candid and sincere. In his book *Obstructions*, the scholar Nick Salvato stretches to argue that embarrassment 'could have a tender and generative quality'. He taps the opinion of sociologist Erving Goffman, who theorized

44

that the embarrassed person 'demonstrates that, while he cannot present a sustainable and coherent self on this occasion, he is at least disturbed by the fact and may prove worthy at another time.'

When an actor cannot do their job under the stage lights we say they have 'stage fright'. Sweaty palms, trembling hands, shortness of breath, dizziness, brain freeze. (Athletes who find their highly refined motor skills suddenly malfunction call this 'the yips' – a bowler who can't let go of the cricket ball, for example. In darts it's called 'dartitis'.) Stage fright was a modern phenomenon, arriving with late nineteenth-century turns in acting technique towards naturalism. The actor 'whose intimacies are public property,' writes Nicholas Ridout in *Stage Fright, Animals, and Other Theatrical Problems*, 'who is isolated in the visibility of the electric light, who stimulates the involuntary disclosure of emotion through the reanimation of his own, these conditions lay the foundations for the eruption of the phenomenon of stage fright.' The actor who 'dies' onstage performs a ghostly repetition of our own vulnerabilities. Apparitions of failure and fear. The actor is trapped between the inability to give the audience what they demand – to be entertained, to have their emotions reflected back on themselves – and their own interior life, a serious resource the stuck performer cannot tap in order to complete their task.

conveying feined emotions from your own suppression isnt beneficial to self. it creates disallusionment if anything

45

¶ Karl was once employed to deliver a boat from Auckland to Hawaii. He was the skipper, accompanied by three others: a bartender and waitress from a drinking spot my brother used to visit, and a fisherman, the only other with seafaring experience. The boat was cursed with electrical problems before leaving. Their SatNav was designed to pick up signals from satellites as they came over the horizon, and take a fix on them. Yet in the late 1980s satellites were mainly orbiting the northern hemisphere, not the Southern Ocean or Pacific. Karl was relying on using a sextant to navigate.

Immediately after leaving Auckland, the wind was screaming. Bad weather continued into the second day. Karl was puzzled why the barometer was not changing; it held exactly the same reading, registering neither a high or low pressure weather system. He was the only one who knew how to drive the boat, and was becoming increasingly tired as the waves grew in size. The fisherman stayed awake the entire time Karl was at the helm to keep him awake.

> At one point he opened the hatch to bring me a cup of coffee and I could see the colour drain from his face, as we got hit with a massive wave from behind, leaving the entire deck underwater, filled like a swimming pool. When the wave hit I got knocked against the starboard wheel and it wrapped around the pedestal. I went for the port wheel but my harness was tangled in the other wheel. I pulled the broken one clean off the pedestal, so that I could reach the port side. We finally got steerage and I went down below. It was thigh deep and the diesel engine and batteries were flooded. We had no power.

Before leaving Auckland, Karl had wrapped a spare battery in plastic bags and stowed it in a locker that sat

above the waterline. They needed to unflood the engine, connect the battery and turn it over to get electricity. 'There's an old saying that there's no bilge pump faster than a man with a bucket.' After five hours of manually bailing out they got rid of the water, bled the engine and fired up enough power for lights and communications.

Karl connected the radio and reached a ham frequency, an amateur radio enthusiast in New Zealand. He gave him his position, and described his confusion over the barometrics. The ham told Karl the reason the barometer wasn't changing was because his boat was riding a border line between two pressure systems. They were trapped directly between a high and a low, both moving at the same speed. All he needed to do was turn south into the Southern Ocean or north into the Pacific. Karl set course for Western Samoa, where he could get the wheels repaired. Within two hours the weather had calmed significantly. 'By the next morning it was shorts, T-shirts, drying everything out and glorious sailing.'

'When I saw those three pairs of eyes staring at me after we got hit, I realised I couldn't show any fear. Nothing other than confidence. It was all on me. I had to act.'

¶ So. Limbo is the lobby next to the hereafter's eleva-
tor banks. It's that feeling in the dentist's waiting room
when you don't know if your destiny lays up Satan's root
canal or ends with a bright white smile. It scales from the
minor anxious withdrawal brought about by a broken
smartphone device to serious time spent between jobs,
and the months, years, letting a past relationship fade
so that another can take colour. Limbo is a videogame,
pulp fiction, a self-aggrandizing surrealist's literary fan-
tasy. It's a way to describe modernist fantasies of cool
affect. If you visit Vermont it's hopped-up pop in a bot-
tle. For Karl it gave him a near-death experience on the
ocean, pinned between dangerous weather systems, try-
ing to hide his stage fright from a green crew. It's also
one of the most famous and saddest dances in the world.

You might not think it, listening to the spry sounds
that made the limbo dance a global craze in the early
1960s. Songs by Frankie Anderson, Lord Melody,
Denzil Laing and the Wrigglers, The Mighty Wrangler,
Lord Tickler and The Jamaican Calypsonians, The
Trinidad Serenaders. At the height of the craze, between
1960 and '63, Bo Biddley, Duane Eddy, Duke Ellington,
and James Brown all recorded limbo songs but it was
rock'n'roller Chubby Checker who hit gold with *Limbo
Rock* in '62. 'Jack be nimble, Jack be quick, Jack go under
limbo stick.' You know the moves. Dancers bend back-
wards at the waist and knees, shuttling forward under
an horizontal bar, which is gradually lowered with each
round, eliminating those who can't make it underneath
without hitting the stick, falling backwards or using
their arms to stay balanced. The greatest limbo dancer
of all time was said to be Julia Edwards, 'The First
Lady of Limbo'. She and her dance troupe were recruit-
ed in 1957 to perform in the Robert Mitchum and Rita

48

Hayworth drama *Fire Down Below*. Later, Edwards was credited with creating the 'flaming limbo' in which the dance bar is set on fire.

Limbo, traditionally performed to calypso – a music that encoded satire and social commentary – emerged as a funeral dance at wakes in Trinidad and Tobago during the mid-1800s. A dance representing death and survival, limbo is said to have its origins in the Middle Passage on slave ships transporting their tragic cargo from Africa to the Americas. These were vessels designed like battery farms for packing bodies and maximizing profits. Captives were chained to the slave cutters in cramped, airless decks in which they could not stand upright. Recordings of Edward Kamau Brathwaite reading his 1973 poem *Caliban* capture the poet staining a gentle calypso-style melody with violence: 'Limbo / limbo like me / stick is the whip / and the dark deck is slavery.'

In 1963, limbo star Roz Croney released an album titled *How Low Can You Go?* The session band drafted in to back her was led by jazz musician Sun Ra, with four members of his Arkestra – Marshall Allen, John Gilmore, Ronnie Boykins and Pat Patrick. The music is upbeat but unhurried; loose, layered percussion kept in check by tight-strummed rhythm guitar, and charmed by friendly brass and reeds. Croney's voice is party-confident, complemented by backing chants that glow with spacey reverb. Those were the voices of Ra and his Arkestra. The same year they played on Croney's limbo record, they recorded the albums *Cosmic Tones for Mental Therapy* and *When Sun Comes Out*. Slow, exploratory, cosmic jams. Galactic be-bop. Through his music and aesthetics, Ra was at that point developing a fusion of science fiction, ancient history and Afrocentric narratives with which to re-imagine black

identity. (Mark Dery later dubbed this 'Afrofuturism'.) His music spoke of space travel, interstellar exile and futuristic technologies, of life on Saturn and Venus. Ra's sound unfolded itself from be-bop and loosened in form. The Arkestra grew batteries of percussion and synthesizers, expanding them further using tape delay effects. They performed in multicoloured robes, psychedelic styles derived from Egyptian pharoahs and African royalty. Ra's purpose was to reflect on the African-American experience, allegorizing the slave ships of the Middle Passage as alien motherships and black people as captive extraterrestrials.

Wilson Harris, writing in *History, Fable and Myth in the Caribbean and Guianas* in 1970, saw the dance as 'the limbo gateway between Africa and the Caribbean', an interzone of suffering, a literal sea-change in circumstances. It borrows from the Christian idea of limbo as an intermediate space between punishment or salvation. Limbo stands for the Middle Passage but Harris suggests it could apply to other mass displacements of people. Harris understood the limbo dance as an endurance that risks death as the dancers bend to pass under the pole, followed by celebration as they stand up, having survived their turn, only to face danger again on the next round. How low can you go? How much suffering can you take? In this sense, the Arkestra's session work with Croney could be a concealed Afrofuturist message, bearing more political weight than a novelty dance record might initially seem to be able to hold.

Recalling dances he saw as a boy in Georgetown, British Guiana, in the 1930s, Harris describes performers imitating spiders or moving on stilts, and he teases the word 'limbo' into the metaphor of the phantom limb, a part of the body which has been lost but can still be felt,

imagined to be in use, even as the amputee simultane-
ously accepts their leg or arm has gone. 'The refusal of
an experience to enter into the past,' as Elizabeth Grosz
puts it in *Volatile Bodies*. For Harris, the phantom limb is
'the re-assembly of dismembered man or god'. It is syn-
cretic, possessesing 'archetypal resonances that embrace
Egyptian Osiris, the resurrected Christ and the many-
armed goddess of India, Kali, who throws a psychical
bridge with her many arms from destruction to crea-
tion.' But the phantom limb is not simply a stand-in for
a lost Africa, and limbo is more than a symbolic sus-
pension between a homeland that cannot be returned to
and new circumstances too hard for adjustment. 'Limbo
was rather the renascence of a new corpus of sensibility
that could translate and accommodate African and oth-
er legacies within a new architecture of cultures.' Limbo
was a space of productive uncertainty, an opportunity to
world-build. To borrow from Ra: 'Somebody else's idea
of somebody else's world is not my idea of things as they
are. Somebody else's idea of things to come need not be
the only way to vision the future.'

¶ Some years ago I was invited with a group of writers to a dinner party at the poet John Giorno's house on the Bowery in New York. We ate in the kitchen, the part of the house his former roommate William S. Burroughs called 'The Bunker'. Next to the dinner table was preserved Burroughs' old bedroom. Giorno, generous and courteous, told stories of old lovers – Jasper Johns, Andy Warhol, Robert Rauschenberg – and of future plans for his painting and poetry. We ate paella. Wine flowed. By the end of dinner, I was sauced.

I said goodbye and made my way to the front door. The exit was unlocked using a timer release button inside the lobby, which led out to a tall iron gate, also simultaneously buzzed open. I pushed the door and stepped outside. Feeling happy but a little unsteady, I paused for a moment to take a few deep breaths before walking home. I noticed too late that the mechanism unlocking the gate had timed-out. The door behind me had now relocked. I reached through the bars of the gate and felt for the door-bell. Nobody answered. Trapped, I waited a few minutes in the hope that another guest would soon leave. Five minutes turned to ten, fifteen. Nobody left.

Soon I began to experience the unusual sensation that the pocket between the door and gate was a time machine for shuttling back and forth in New York history. Behind the door was old New York, a romance of art and affordability, and also of run-down crime-ridden desuetude that can only come from not having experienced it first hand. It reminds us of our present epoch in which the world appears to be falling apart. If it kept on turning back then, hopefully it will continue to do so now.

Ahead through the metal gate was present-tense New York. Scaffolding encasing new condos. Luxury SUVs growling up the Bowery. Braying men in matching

shorts and baseball caps, and groups of women vocal frying at high volume. All making sure the homeless outside the Salvation Army shelter, wedged between the New Museum and a newly acquired property for the Ace Hotel, remained invisible.

Augurs of worse to come tomorrow. A future hidden one dimension forward from this Friday night on the Bowery. A city shaped by urban growth congruity and creative branding fidelity. Opposite Giorno's building is a *reiki* centre for startup-owned dogs and two of Manhattan's most celebrated tattoo parlours for children. New York has become home to the highest density of coffee shops in the USA, transforming downtown neighbourhoods into coffee bean and oat milk silos. Barges bring beans roasted on Staten Island (a once-residential borough of the city requisitioned by the barista industry) across the bay to delivery points on the Hudson and East Rivers. Cashmere sacks of beans are unloaded from the barges by workers dressed in vintage 1940s workwear, and taken to the storage silos, ready for slow distribution across the city by pony and trap. From here can be seen block after block of coffee shops: Blackwater, Slouchy Ramona's, Feeling Fursty, Kommie Koffee Kart, Barrio Neighbourhood Hutong, Skifflebrawn, The Living Mountain, Toil, Precious Harmony Bliss, Cold Press Testing Systems, Michael Alig's Theatre of Cruelty, I Shit You Not, Permanent Vacation, Coldpress Douchebrew, Varmint Town, Spitback, The Freelance Homesteader, You're Late You Bastard!, Dylan & Forest & Jenna & Zach's, Dylan & Josh & Jenna & Wyatt's, Milksprang & Cuddlemugs, Inca Sweat, [RE]-FU/eL, and Penny Farthing Colonialist Roast Co,. Food trucks promise Roman-revival lizard sliders and Scottish deep-fried Mars bars. Admired for its décor modelled

[handwritten marginalia:] 'requisitioned' seems a little too gentrified (for ex.) Alphabet City is now deemed the Lower East Side –

53

after Charles Manson's Spahn Ranch, nearby bar The Randy Senator advertises artisanal ayahuasca cocktails fusing recipes from top Alaskan mixologists with bio-weapon synthesis techniques. There is not a single person in sight.

I ripped a hole in the seat of my trousers on the turn as I finally had to climb over the spiked gate, and grazed my thigh on the drop, as I sobered out of the time machine.

I.M.O. - a beautiful take on the less-than-impressive technological gentrification of NYC

¶ 'The refusal of an experience to enter into the past' is a workable definition of a haunting. The mission of dead souls is to escape whatever dimension they are trapped in and return home (the Old French and Middle English meaning of 'haunt') where they can rest forever in peace. Think of indecisive Hamlet's dead father, 'doomed for a certain term to walk the night'. Susan Owens in *The Ghost: A Cultural History* writes: 'These shape-shifting spirits seem intent on getting a purchase on the physical world in any way they can in order to attract attention before, in most cases though not all, gaining access to human form so that they are able to communicate their predicament.' Wrapped in white cowls, assuming animal guise, rearranging the furniture and going bang in the night; ghosts will do whatever it takes to escape the tortuous in-between. Back to Coleridge: 'The sole true Something – This! In Limbo Den / It frightens Ghosts as Ghosts here frighten men.'

The Protestant Reformation in sixteenth-century Europe tried to kill the Catholic science fictions of limbo and purgatory – principle trade routes for Western phantoms – yet this did not do away with a belief that ghosts continued to find ways to get the attention of the living. (The literary hit of late sixteenth-century London was a series of pamphlets titled *News out of Purgatory*. According to Owens, 'these stories described the travels of charismatic individuals in the afterlife, parodying canonical literary prototypes from medieval dream-visions to the excursions into the underworld described in classical and Renaissance literature.') Faith in the spirit world persisted because we did not want to let go of the deceased, yet didn't know where to let them go to.

The Great Beyond, the Hereafter, the Other Side,

the Next World. We geo-locate ghosts in optimistic-
ally named dimensions. It helps bury the fear that the
Land of the Living might itself be limbo. An explica-
ble nano-flash of consciousness that looks to us like a
transition between two significant points of entry and
exit, but is merely an accident in infinite nothing. Before
your birth, you were not. After your death, you will,
again, not be. Life just a funny thing, to paraphrase
Quentin Crisp, that happened on the way to the grave.
'We peer back into the darkness of the past,' writes Brian
Dillon, 'convinced that there must be some evidence
there of our own future being. And we find, according
to Augustine's doleful reflections, nothing. We seem to
have stumbled on to the stage of our own lives before
the curtain has come up.' We find a child on the beach in
1985 with his back turned to us.

Qualities we associate with the supernatural are tied
to fundamental questions we have about living. 'Why is
there something here where there should be nothing?'
asks Mark Fisher in *The Weird and The Eerie*. 'Why is
there nothing here when there should be something?'
A negligent manager at work is nicknamed a 'ghost
boss'. The term used to describe a person who drops a
relationship and cuts off contact is 'ghosting.' A sudden
vanishing, leaving the ghosted person with only ecto-
plasmic uncertainty. What did I say? What did I do?

Phantoms are futuristic. They've seen where we'll
go. (Think of Charles Dickens' Ghost of Christmas Yet
to Come in *A Christmas Carol*.) Yet in movies and books
they customarily rattle the chains of the period in which
they died, speak in old-fashioned dialects, or man-
ifest as playbacks of ancient psychic energy – like the
haunted chamber in Nigel Kneale's *The Stone Tape*, built
from bricks that have recorded a millennia of violence.

56

Injustice or trauma is pain kept, unhealed, in psychological suspension. Unquiet spirits cannot be released from limbo unless an old misdeed or emotional injury is corrected.

They make books, poems, songs, plays. Paraphrasing Eve Kosovsky Sedgwick, literature is 'the impossible first person... of someone dead or in the process of dying.' (Even the best attempt by an author to remove persona from their writing leaves prints.) All writing, one day, becomes permanent ghost writing.

You might slander ghosts for being agents of nostalgia, but the living nostalgic does not need paranormal help to transfix them to the past. Their longing for a quasi-lost time and place is fantasy. The nostalgic harbours a utopian instinct, as understood in the proper sense of the word 'utopia': not a good place, but rather, no-such-place. Michael Kamen calls nostalgia 'history without guilt.' The nostalgic isn't stuck in the past, they're caught in an antechamber to one side, neither fully immersed in memory nor living in the present.

beautiful chapter

✱ "Land of the living might itself be limbo"

¶ In 1943 the Wiltshire village of Imber ceased to exist. Last orders were called at the local pub, the surrounding farms stopped work and St Giles' Church, which had sat at the heart of the community for 700 years, closed its doors. Requisitioned by the Ministry of Defence, Imber had been chosen as a site to train Allied soldiers in street fighting, preparing for the push into Nazi-occupied Europe. The 160 villagers were evacuated and sent to stay with relatives, allegedly with the promise that they could return to their homes as soon as hostilities had ended. Troops moved in and the village, first settled in the tenth century, was now consumed into the Salisbury Plain military training zone.

World War II shaded into the Cold War and the military was not willing to vacate Imber. Any hope the villagers had of returning to their homes was lost. The community, however, was never completely broken, and a sustained campaign calling for reparations to be made to those displaced by the military's war-gaming was begun in 1961 by local councillor Austin Underwood and continued in later years by his daughter Ruth.

The public is still able to visit St Giles' Church for a small window of time every August. To drive along the isolated and usually inaccessible road towards Imber through Salisbury Plain – one of the biggest training areas in Europe – is to pass through a Britain seldom seen. Wiltshire's neolithic long barrows and burial mounds are echoed in the forms of shattered military hardware. Burnt-out tanks and crushed vehicles litter the hills like dead cattle. Miles away from main roads the silence is thick. The Norman-era church remains, as do the crumbling shells of the school, the Nag's Head pub, and the local big house, Imber Court. Little else survives. Schematic-looking training buildings line the

streets – two-up two-downs each with four windows and a door, like a child's drawing of a house. Back gardens are heavily overgrown, and barbed wire rings off ditches and fields pocked with unexploded ordnance.

This ghost village offers a glimpse of state-of-emergency Britain. It hints at future possibilities, what the government can seize of day-to-day life, suspending law to preserve sovereignty. Dad served briefly as a medic in the Territorial Army, and tells me about training exercises here in 1980. Sweating through the lanes in radiation hazmat suits, past bullet-ridden cottages and the boarded-up pub, then still with beer taps and horse brasses on the walls inside. He told me about grown men playing dead and running through the village at night shouting 'bang! bang!' when they couldn't use ammunition. These stories surface alongside unsettling memories of 'Protect and Survive' public service films, and episodes of *Quatermass* or *Dr Who* set in an England under martial rule, besieged by invisible forces.

One Sunday in 2003, a few weeks after visiting Imber, some months after the second invasion of Iraq, I took a walk west from my home in east London towards St Paul's Cathedral. Reaching the City, I discovered the streets had been cordoned off for a training exercise simulating a chemical weapon attack. Helicopters buzzed overhead. Walking the edge of the cordon, through deserted alleys and lanes, large groups of police and firemen in biological protection suits could be glimpsed. The following day contingency plans for the mass evacuation of London were announced. I was back in Imber, not just in 2003 but in 1943 and 1980. Another time machine, like Giorno's lobby, or the street in front of the Headington Shark.

¶ Marcus Lindeen's documentary *The Raft* tells the story of the 1973 Acali Experiment, an experiment designed by Mexican anthropologist Santiago Genovés to explore the origins of violence and the social conditions of sexual attraction in complete isolation. Five men and six women, all volunteers, were selected for the experiment from a variety of socio-cultural backgrounds: Algerian, Israeli, American, Japanese, Swedish, Cypriot, Mexican, Uruguayan, and Angolan. They were to drift on ocean currents from Spain to Mexico on a purpose-built 40-foot raft named the Acali. Genovés assigned the men menial tasks, and put the women in positions of authority – captain, doctor, engineer – in the hope that conflict would break out along gender lines. It didn't. After a number of weeks, nothing much had happened, save for the occasional sexual encounter between crew members. The anthropologist tried to artificially create friction in order to gather material to study but the crew saw right through Genovés's attempts to sow discord. After briefly considering throwing him overboard, they mutinied and ostracized him. For the remainder of the journey, the Acali micro-matriarchy existed in peace.

'To drift on a small raft is a hypnotizing experience,' wrote Genovés in his expedition journal. 'You can get stuck for hours just staring into the horizon. But looking at the same scenery day in and day out can play tricks on the brain. Old sailors have a name for it. They call it "ocean vertigo."'

One of the Acali's crew was a 23-year-old American named Fé. In *The Raft*, she recounts that

> after some time, after we hit the southern region, I started to have visions. And I realised that I was probably the first

60

African-American actually floating back from Africa to the Americas the same way the slave ships had gone. That was one of the most incredible experiences of my life. I would sit on the starboard side and I'd look over the water; sometimes it would be quiet enough that I'd start to hear voices, coming from down there. I heard my ancestors who had gone over in the slave ships. I could hear them calling me, they could feel me sailing over their bodies and their tragedies. ... These people got to live again through my body, through me, and it was one of the best things that ever happened to me, to let my heart beat for them for that time.

Fé is asked if she ever shared that with anyone on the Acali. 'You don't say that to people. It's so intimate. I actually never expected to be believed.'

¶ The ocean. 'A dimension as vast as space and as time-less as infinity. It is the middle ground between light and shadow, between science and superstition, and it lies between the pit of man's fears and the summit of his knowledge.' Also Rod Serling's introduction to the first episode of *The Twilight Zone*, broadcast in 1959. Here, ordinary, unsuspecting people find themselves caught between existence and death, past and present, society and isolation.

The Twilight Zone was preoccupied with what Serling called 'the barrier of loneliness'. In the series pilot, 'Where is Everybody?', a man arrives in a deserted small town only later to discover he is being observed for an experiment in solitary confinement. 'Up there is an enemy, known as isolation,' intones Serling at the end of the show. 'The Hitch Hiker' tells of Nan Adams, a young woman driving cross-country across the USA. She is unable to shake a menacing-looking hitcher who repeatedly appears ahead of her on the road no matter how far she travels. Eventually Adams learns she was killed in a car accident days earlier. The vagrant was Death. Henry Bemis is the subject of 'Time Enough at Last'. He is a bookworm with bad eyesight, who longs for nothing else than time alone to read. Bemis becomes the only survivor of a nuclear attack – the perfect con-ditions for catching up on his reading – but accidentally breaks his glasses in the ruins of the town library, leav-ing him blind and alone.

An apple pie Everytown was the most com-mon gateway into *The Twilight Zone*. Picket-fenced, lawn-sprinkled suburbs, populated with neighbours who know each other's names. Occasionally, a big city stand-in for Los Angeles, Chicago, New York or all three at the same time. The men wore wide-brim hats and

worked as business executives or scientists. The women stayed at home to raise tousle-haired kids dressed in plaid and gingham. This world was white, gee-whizz, Eisenhower-Republican. The kind of Twilight Zone that generations of artists and misfits have run away from to avoid suffocation.

In the mid-1960s, Mum, Karl and Mark lived in a small city in the west of Canada called Salmon Arm. I would hear stories of their time in British Columbia as a child, and spores of North American culture travelled with them when Mum decided to return to Britain at the end of the decade. I was too young to understand the differences between the US and Canadian culture; America was everywhere and nowhere. Far-away places in a picture book on the shelf, a hand-me-down toy car that looked like nothing on British roads. Syndicated US comedies and science fiction shows were broadcast on British television during my childhood. As Karl was away, I discovered some of these TV shows through Mark. I patched an aesthetic link between these artefacts of 1960s Americana and my family's own experiences across the Atlantic. Mark's refined, artist's sense of camp irony took pleasure in re-runs of *Batman*, *The Munsters*, *The Addams Family*, *The Invaders*, and *The Twilight Zone*. I imagined Salmon Arm as one of these Twilight Everytowns. Mum, Karl and Mark in danger of being swallowed up by the Zone or body-snatched by aliens. The idea of their disappearance terrified me.

When *The Twilight Zone* was rebooted in 1985, its themes of loneliness and limbo remained. The threat of atomic annihilation, carried over from the 1950s phase of the Cold War, was ever-present. In 'A Little Peace and Quiet', a harried woman discovers a powerful talisman in her backyard, which allows her to put the world

'on pause'. A nuclear attack is launched on the USA. She freezes time, and the episode ends with her gazing up at deadly missiles hanging Damoclean in the sky. (Back to Buckley's shark where death is suspended in the air. Sun Ra too, if bluntly: 'Nuclear war – it's a motherfucker.') 'Dreams for Sale' tells the story of a woman from a miserable future who becomes stuck forever in a broken virtual reality program that loops a fantasy bucolic picnic with her husband.

In science fiction, horror, and modernist literature, the state of limbo finds new forms. Jordan Peele's horror movie *Get Out* bends it into social commentary. Missy Armitage, the manipulative mother-WASP, hypnotizes the film's black hero, Chris, with a cup of tea and probing questions about his past. His body becomes paralyzed. Terror and tears fill his eyes. 'Now, sink into the floor,' she commands. '*Sink!*' The cosy New England living room in which he sits begins to recede from view as Chris falls slowly into a vast, inky vacuum. His body hangs in deep space, like an astronaut sucked out of his ship's airlock. Chris tries to scream but his lungs can project only silence. Missy appears far above him like a figure on a distant television screen and declares: 'Now you're in The Sunken Place' – where black consciousness is imprisoned, silenced and rendered invisible.

There is the mirror world of the Upside Down in the nostalgic TV show *Stranger Things*. Whatever cruelty has caused sunny Winnie to be stuck beneath a mound of earth in Samuel Beckett's *Happy Days*. The 7 1/2th Floor – an office space between reality and the inside of actor John Malkovich's head – in *Being John Malkovich*. A triangle of land beneath the Westway in London, where J. G. Ballard strands urban castaway Robert Maitland in the novel *Concrete Island*. The sentient Zone

in *Stalker* by Andrei Tarkovsky, and the Black Lodge, the red-curtained interzone – echoes of *barzakh*, the partition or threshold – between life and death in David Lynch's *Twin Peaks* series, where dwarves and murdered high-schoolers speak in backwards riddles. When Heaven's administrative corps fail to seize an RAF airman plunging to his death at the start of Michael Powell and Emeric Pressburger's *A Matter of Life and Death*, they put his life on pause and subject him to metaphysical trial. All of these places – lank space, where nowhere is forever – represent lack of agency. We rationalize misfortune with the suspicion that higher forces, earthly or supernatural, are preventing us from getting what we need.

Limbo stands for frustration and helplessness in the administered, managed, certified, credentialled and surveilled life. It's the category of the Kafkaesque. Think of poor Josef K., arrested for an unspecified crime in *The Trial*. Or the land surveyor K, in Kafka's unfinished novel *The Castle*, stranded in a village, perpetually kept from obtaining the correct administrative permissions to visit the authorities who govern it.

For Kafka, the experience of writer's block was having 'to see the pages being covered endlessly with things one hates, that fill one with loathing, or at any rate with dull indifference.' In Peter Capaldi's short comedy, *Franz Kafka's It's a Wonderful Life*, Richard E. Grant plays the tortured author, crippled with block as he tries to write his one-day-famous short story 'The Metamorphosis'. 'As Gregor Samsa awoke one morning,' Kafka mumbles to himself at his desk, 'he found himself transformed in his bed into a gigantic... What?' The writer looks around his room in search of inspiration. He looks out of the window, he looks at the clock

on the wall. His gaze lands on the fruit bowl. In his mind's eye Kafka suddenly sees a bed, a figure thrashing under a heavy blanket, and an arm tugging free the covers to reveal a giant man-banana. Kafka screws his writing paper into a ball and starts again. 'Gregor Samsa... blah blah blah... transformed into a gigantic...' Loud music from his neighbours interrupts his train of thought. A sinister knife salesman knocks on his door selling blades and looking for his missing 'little friend'. Despite the music and unwanted callers, Kafka presses on. He flattens an insect that strays onto his writing paper. The crushed bug gives him the inspiration he needs – Samsa is transformed into a gigantic insect! – but then the knife salesman returns, convinced that his friend, Jiminy Cockroach (because 'times are hard'), is in Kafka's flat. Was the squashed roach Jiminy? Kafka has no idea. He is terrified at what punishment the uncertainties of his crime might bring.

¶ Nobody tells anyone anything in Kafka's limbo. Fear has no specifc monster to attach itself to.

I first tried to visit New York on the morning of September 11, 2001. Halfway to a holiday across the Atlantic, my flight booked months before, the captain came on the intercom. 'Ladies and gentlemen, I would like to say that our cabin crew has been doing a wonderful job today, and assure you that our aeroplane is in excellent working order. Unfortunately I cannot say the same for the United States of America, which has just closed its airspace and we are being directed back to Heathrow.' The plane banked a hard right. On the map in the headrest of the seat in front I watched its animated U-turn and felt sick. The pilot told us he had no further information at that moment. Got to be a nuclear attack. Perhaps a devastating airborne toxic event. War with Canada? Alien invasion. We sat in silence for an hour. I bounced between terror and selfish resentment at the cancellation of my holiday, until the captain returned to the PA. 'We understand from the BBC World Service that two hijacked planes have been flown into the World Trade Centre in Manhattan, a third has hit the Pentagon, and a fourth is currently being chased across Pennsylvania.' Silence. Then the cabin crew flew drinks up and down the aisle. Whiskeys were downed like water. Next to me was a group of elderly US citizens, returning from a European package holiday, crying and attempting to console each other. Was there any kind of telephone on board? How can we contact our relatives? For three, maybe four, hours we did not know what had happened. I envisaged co-ordinated attacks across the world: planes hitting the Eiffel Tower, the Taj Mahal, Sydney Opera House. The thought crossed my mind that our plane might be aimed at Big

Ben. There was nothing to hold on to, no way to contact family or friends. We skimmed the turrets of tanks lining the runway at Heathrow. Armed police and soldiers patrolled the airport. At the time I did not own a mobile. An *Evening Standard* sandwich board, and a crowd stood around a television set in an airport bar told me about the hijackings. The truth was more horrifying than I imagined, but at least it was truth.

In darkness flourishes a bestiary of beliefs. Belief in vengeful deities who sentence sinners to Boschian tortures and refuse babies entry to heaven because the house rules say you have to book in advance with a baptism. 'Gods always behave like the people who make them,' said Zora Neale Hurston.

In the Rabelaisian short film *Giantbum* by Nathaniel Mellors – tagline, 'from scatology to eschatology' – a charismatic and coprophagic cult leader, The Father, lures a small group of explorers into the bowels of a giant, where they become trapped. Here in the monster's system, the doomed group is informed that 'there is no outside' – the giant's digestive tract is the entirety of the universe. The explorers lose all relative measures of morality, and only have The Father's lies to trust in. He tries to convince his followers that they have come in search of the Ploppen, holy creatures who eat their own bodies, excrete themselves and rebuild their bodies with their faeces. Mellors made *Giantbum* to be a filthy allegory of political spin, in which any corruption can be reframed for the greater good, and of a social media bubble in which ideas are reframed with no admission of other beliefs.

A vacuum in knowledge sucks in all kinds of theories to explain the lack of agency we might feel about the world. The suspicion that there are other worlds

that They – and only They know who They are – have not told you about. Blame it on the Commies, the Immigrants, the Gays, the Feminists and the Feminist Gay Immigrant Commies. Blame it on the chemtrails, the crisis actors, and the false flags. Demand the alternative facts be told about the flat Earth, UFOs, faked moon-landings, the deep state, Elvis, Lord Lucan, Nibiru, and QAnon. Then call for action in action-movie-deadpan: truth isn't truth so buckle up – now it's our turn. It's time to take out the trash and take back our country. Freedom ain't free. The insurrection has begun. Liberty or death. (Satirist John Oliver defines YouTube conspiracy theory videos as 'science fiction for people who don't know they're watching science fiction'.) Extremism, by definition, exists at the hem of the political spectrum, on the outskirts of knowledge. Once your ideology is cranked to the most hyperbolic volume and your rhetoric pumps to eleven – stretching to the limit what words can express of your anger, frustration, or zealotry – then there's nowhere left to go but to have the world confirm your assertions or risk ridicule. So you gaslight your critics and jam yourself upside down in the attic of your house, locking down a closed system in which your moral compass points to magnetic wherever-you-want-north-to-be. For an encore, to paraphrase Douglas Adams, you then go on to prove that black is white and get yourself killed on the next zebra crossing.

The great and good, waiting patiently in *limbus patrum*, knew they'd get the upgrade to Heaven. According to Aquinas, the children condemned to *limbus infantum* did not know God, and this is what allowed them to find peace. The unknown can affirm life with negative shapes. A useful tool for artists: 'At the core of everything there's something that is unknowable,

unconquerable, impenetrable, inexplicable, and enigmatic' says the painter Amy Sillman. 'I think that one of the moving things about all art is that somebody made it, and that they're not like me.' No news, as my parents would say, can be good news. It's John Keats' 'negative capability' – ability to function 'in uncertainties, mysteries, doubts, without any irritable reaching after fact and reason.' (Uncertainty and its cousin, indecision, are also luxuries: many do not have the choice but to make stark choices on a daily basis.) Yet even given all the imaginative, interpretative freedom you might desire, the need for an authority figure to come and take us by the hand persists. Writing in the 1930s, the psychologist, surgeon and surrealist artist Grace Pailthorpe observed how she heard many reactions to surrealism – then a relatively new movement – 'but the most pathetic of all is from those who ask, "What am I supposed to see and feel from this?" In other words, "What does papa say I may think and feel about it?"'

When the convict Wolf, doggedly pursued by Droopy in the 1943 Tex Avery short *Dumb-Hounded*, runs off the edge of the celluloid, he can only run so far into cartoon limbo before being bounced back into the frame. The disintegrating film strip that puts Popeye and friends in peril at the climax of their 1938 *Goonland* adventure has to be stitched together by the hands of God the Animator. Rebecca Solnit, in her *Field Guide to Getting Lost*, writes: 'Movies are made out of darkness as well as light; it is the surpassingly brief intervals of darkness between rich luminous still image that make it possible to assemble the many images into one moving picture. Without that darkness, there would only be a blur.' Droopy and Popeye know their stories are edged with darkness; they are occultists seeking escape into

70

that 'deep imaginative night'.

¶ In 2008, I went to sea. I had been working in London as an editor for the art magazine *frieze*. My employers awarded me a short sabbatical for good behaviour, and I initially imagined I would use the time to retreat to a picturesque bothy or quiet cottage in the woods, believing these were the conditions under which books got written. This Great Literary Plan to look at trees and hope for the best was rivalled by an opposing desire to travel, but a beach in the sun or swapping London for another city with a bunch of art museums held little appeal. Not long before the sabbatical began, I read a newspaper article about cargo ship travel. 'Tramping,' it used to be called – working your passage on freighters that were not attached to fixed schedules, vessels that would sail anywhere and carry anything. At one time it was a rough but cheap way to see the world. The tramp trade still existed but they no longer offered ad hoc jobs for travellers. Automation had reduced the size of merchant ship crews, leaving large vessels part-empty. A handful of enterprising shipping lines were now offering room and board in their vacant cabin space. Here was my solution. I could retreat onto water, go as far away from any inhabited place as possible. Turn my idea of the planet inside-out, like a nautical chart on which the sea is annotated in great detail, and land is rendered as a cursory and schematic interruption to the wilderness. See it through Karl's eyes.

I saved for the sabbatical and asked a travel agency that brokered container trips how far my money would take me. Duration interested me more than destination, so I let the distance determine where I'd finish up. Panama Canal routes into the South Pacific and Polynesia were too expensive. The North Sea too close to home. To Asia through the Suez Canal seemed best.

Plans were also dictated by sailing schedules. To go anywhere I had to find a vessel that was docking in the UK near the time I wanted to leave.

The *Ital Contessa* was arriving at Thamesport in late March, en route to Hong Kong from Hamburg, one week into my sabbatical. I decided to join them as far as Shanghai, a city I'd always wanted to see, where I would meet my girlfriend for a week's holiday, then fly home. Six weeks there, twelve hours back. From Thamesport the ship was to sail into the English Channel, curve west into the Atlantic, and down the coasts of France, Spain, and Portugal. At Trafalgar, it would turn east into the Mediterranean and hug the North African coast – Morocco, Algeria, Tunisia, Libya, then pause at Port Saïd, Egypt, too briefly for me to leave the ship. From here we would join a southbound convoy down the Suez Canal, stop for a day in the Bitter Lakes to allow the northbound ships to pass, continue into the Red Sea, pass through the Gulf of Aden, and out into the Indian Ocean. Heading east, the ship would scrape the bottom of Sri Lanka, head over the tip of Sumatra and drop into the Strait of Malacca. It would make its first significant stop four weeks after leaving Thamesport, at Tanjung Pelepas, Malaysia. After unloading, the ship would loop below Singapore, and steer north into the South China Sea to Kaohsiung in southern Taiwan. From Kaohsiung to Ningbo in China, bounce back into international waters, then into Chinese seas again to dock at Yangshan, a deep sea port on an island thirty miles off the coast. I would leave the boat here and have to find my own way 125 miles to Shanghai. I had never visited any of these places, but was seduced by the sound of the itinerary as I read it off to myself, too callow to understand how this was a Boy's Own holiday in other people's hard-working

lives. Weeks into the voyage, I would discover that progress through this list promised certainty when the horizon offered nothing, and a way to measure out the monotony of ship routine.

Anxiety sharpened as I waited on stand-by for the shipping company phone call letting me know the *Ital Contessa* had docked, and that I should make my way to the port. Perhaps I had made the wrong decision. Money wasted on six miserable weeks ahead. The call came and I was instructed to arrive early the following morning. Mum and Dad drove me to Thamesport before dawn. The terminal sits on the north bank of the River Medway, near the mouth of the Thames Estuary. The land it occupies is flat, eerie, dotted by power stations, industrial parks, small villages and towns that don't see many strangers. As we neared the port, Mum and Dad's compact Skoda was dwarfed by increasing numbers of trucks ferrying containers until we were the only civilian car on the road. Arriving early, we parked against a high security fence. Dad spotted a pair of old World War II pillboxes on a nearby embankment guarding the Estuary and we walked over to take a look. (Family lore had it that during World War II, Grandad had overseen the construction of a pillbox in the north of England that accidentally faced the wrong way, its back to the road it was supposed to cover. Civil defence was in our blood.) Dad was at the time writing a book about Jane Whorwood, a double agent for Charles I during the English Civil War. He became excited when he realised that Thamesport was near the point on the Medway where his subject's plan to smuggle the king out of the country had failed. Dad's school teacher ability to enthuse anyone who might listen with his evocations of historical events was a welcome distraction

from my worries that morning.

I was concerned I would feel uneasy in the all-male culture of the container. Large groups of men have never made me particularly comfortable. Too much talk and not enough listening. Too much noise that proves only the persistence of playground hierarchies into adulthood. But the ship represented other, unknown fears that my imagination had little trouble amplifying. B. Traven's maritime horror *The Death Ship* sprang to mind. On a hellish tramp steamer named the *Yorikke*, Traven – a recluse whose true identity is still disputed – describes a legend inscribed over the crew's quarters:

'HE WHO ENTERS HERE WILL NO LONGER HAVE EXISTENCE; HIS NAME AND SOUL ARE VANISHED AND ARE GONE FOR EVER. OF HIM THERE IS NOT LEFT A BREATH IN ALL THE VAST WORLD. HE CAN NEVER RETURN, NOR CAN HE EVER GO ONWARD; FOR WHERE HE STANDS THERE HE MUST STAY. NO GOD KNOWS HIM, AND UNKNOWN HE WILL BE IN HELL. HE IS NOT DAY; HE IS NOT NIGHT, HE IS NOTHING AND NEVER. HE IS TOO GREAT FOR INFINITY, TOO SMALL FOR A GRAIN OF SAND, WHICH, HOWEVER SMALL, HAS ITS PLACE IN THE UNIVERSE. HE IS WHAT HAS NEVER BEEN AND NEVER THOUGHT,'

What if this was a disclaimer I had inadvertently signed when I booked my trip? Or what if I was to suffer the fate of Evelyn Waugh's avatar in *The Ordeal of Gilbert Pinfold* – the writer who takes himself on an ocean cruise to recover from a breakdown only to unravel even further, convinced the ship's crew was conspiring against him?

Both Dad and Karl had experiences of male institutional cultures; the priesthood, the army and navy. I spent my days with artists, writers, art world professionals, edited reviews analyzing the most recondite corners of contemporary art; Mark's artistic urbanity was the model for masculinity I followed. I predicted a literary kinship with B. S. Johnson, who joined a fishing vessel in the Barents Sea for what would become the novel *Trawl*, cocky with the idea that it would provide Conradian grit for his literary experiments. Johnson was sick as a dog and got in everyone's way.

Mum and Dad left me at the gate, all three of us anxiety-sick. A guard picked me up from the security checkpoint in a minibus and drove me to the *Ital Contessa* down long avenues of stacked containers. Never walk in a port, the guard warned me. He'd known people crushed under those steel crates. Container ships were only ever thin wedges of colour sliding along the horizon, spoiling a view from the beach. I'd never been close to one. Arriving at the quayside, the *Ital Contessa* looked the size of a city block, as if a London street had been welded on top of a keel and propeller. Thick ropes tethered the tall blue hull to the dock, though its size seemed incapable of drift. Cranes played Tetris on top of it with coloured containers branded Maersk, CMA-CGM, Evergreen, COSCO, Hapag-Lloyd. Over the rear third of the ship rose the white-painted superstructure, containing the bridge, cabins, engine room, and crew recreation areas. A greasy rope gangway was tied at a vertiginous angle between the deck and quayside.

I was met at the top of the gangway by the ship's steward and one of the seamen. A warm hello and offer to take my rucksack was my first surprise. I signed myself onboard, then was taken to my cabin, one floor down

from the bridge at the top of the superstructure. The interior smelled strongly of disinfectant. Flood-proof and easily washed with water and a mop. A cramped elevator and a steep flight of stairs connected the deck to the bridge. My official designation, as a sign over the cabin door stated, was Supercargo. It was a small, comfortable room with a desk, bunk, shower, a closet and two lozenge-shaped portholes looking over the ship's stern. A print of a woman curled in a chair hung in a metal frame above the desk, painted in dentist-waiting-room-Impressionist style. The cabin was painted white, and the furniture made from a tan laminate wood, as if it had been fitted out from Ikea. I was instructed to always take my shoes off before entering any rooms on the ship, as grime and fuel residue from the decks spread easily. Here I was to wait until midnight, when the ship sailed. I could wander onto the walkway outside my cabin, but had to stay out of the way of working areas until loading was complete.

The day brought visitors. A gruff hello from the scruffy Captain Buchla who took my passport and informed me I was allowed on the bridge whenever I wished. Chief Officer Walther, a lanky middle-aged man from Cologne with a thick, blonde mustache, had little small talk but was happy to pass the time with ship-related conversation. Angelo, the steward, was in his mid-twenties, warm and chatty. He gave me a run-down of ship protocols and was to keep an eye on me for the duration of my trip. (The ship's six officers were German, all the others Filipino seafarers – twenty-one out of over 460,000 employed by the shipping industry.) The youngest crewmember was 19, Captain Buchla in his 60s; he had joined the merchant navy as a teenager to escape the GDR.) There was one

other passenger, a sixty-something German named Michael: recently retired, boorish. He wore bottle-thick glasses and a fisherman's vest, chain-smoked in his cabin, and would spend his time scanning the water with binoculars, noting vessel types – coasters, ro-ros, reefers, bulk carriers, tankers of all sizes – and cornering anyone who would listen with his knowledge of the shipping industry. Michael enjoyed the ship's rules, particularly letting me know when I had infringed maritime etiquette. When asked, he give nothing away about his life on land. This may have been simply out of privacy, but I had the sense he was running away from something.

The ship pushed off so slowly that I didn't at first notice we were moving. I could not read any signals that the *Ital Contessa* was leaving dock: the engines had been gunning loudly for some time, the gantry cranes had lifted their giraffe necks and the stevedores had finished hours ago. From my cabin I could not see cables or ropes being winched in. There was no sense of excitement at this adventure's start. Nerves made me vomit waiting for the ship to leave. 'You have to deal with the situation you're in,' Karl would later tell me about going to sea.

Getting away on an ocean crossing, that first night and the first full day at sea are the hardest because you've got this "if I want to turn around I have to do it now" feeling. Then you cross that precipice, it becomes too late to change direction and everything changes. This, you realise, is your starting point now. A full recalibration is needed.

I zipped up my anorak and went out onto the walkway by my cabin. Beyond the port's halo of sodium lamps, the Medway was pitch black save for winking navigational

buoys and distant lights from ships crossing the mouth of the Thames Estuary. It looked as if we were gliding into deep space. We were on Karl's Rocket. Full recalibration began.

¶ 'Forgiveness is an attribute of living matter,' wrote Clarice Lispector. All of us conduct lives that fringe the good and the bad; you, me, the penitent thief, the whiskey priest, and most everyone else. Which sounds like an encouragement towards a dangerous relativism. James Baldwin's account of leaving Harlem for Paris, 'Every Good-bye Ain't Gone', contains a passage in which the writer describes himself in a bar brawl.

> I suddenly realized that the Frenchman I was facing had not the remotest notion – and could not possibly have had the remotest notion – of the tension in my mind between Orleans, a French city, and New Orleans, where my father had been born, between louis, the coin, and Louis, the French king, for whom was named the state of Louisiana, the result of which celebrated purchase had been the death of so many black people... But what I began to see was that, if they had no notion of my torment, I certainly had no no-tion of theirs, and that I was treating people exactly as I had been treated at home.

Baldwin may not have been surprised to learn that in early twenty-first century USA people find themselves asking, is it OK to punch a Nazi? A question easier to reason from behind a desk than in front of a fist.

In the essay 'Leslie', the film director John Waters writes about his long, unusual friendship with Leslie van Houten, one of the Manson Family women con-victed for the 1969 LaBianca murders, and his efforts to support her parole applications. As a young artist in the early 1970s, Waters was, like many, fascinated by the dynamics of the Manson cult, but he would push this into deliberate prurience, dropping references to the Manson family in his films trying to get a rise out of the straight world and his own counterculture peers.

Multiple Maniacs features a blackmail subplot involving Manson victim Sharon Tate and *Pink Flamingos* was dedicated to three of the Family's 'girls' – 'Sadie, Katie and Les'. In the mid-1980s, a little older and wiser, Waters went to meet Van Houten – 'Les' – in prison on a writing assignment for *Rolling Stone* magazine, and began a correspondence which led him to reflect on the purpose of punishment and nature of forgiveness. 'Naturally the victims' families words and anger are incredibly strong and hard to argue against,' he writes. 'What they say can actually *never* be wrong. If Leslie had killed my mother, could I forgive her?' Yet can we ever know what it was like to be in the mind of a 19-year-old bombed out of her mind 'after months of LSD trips, isolation in the desert, and hours and hours of [Manson's] continuous insane political rantings'? Imprisoned in 1971, Van Houten has now served more time 'than any Nazi war criminal who was not sentenced to death at Nuremberg'. 'I am paying for this as best as I can,' said Van Houten during a 1993 parole board hearing. 'There is nothing more I can do outside of being dead ... and I know this is what you wish, but I can't take my life. I'm sorry...' 'But how sorry is sorry enough?' asks Waters.

Generations of neuroscientists, psychoanalysts, theologians, philosophers and psychedelic gurus will attest that it's hard enough to know ourselves, let alone others. 'What kind of spider knows about arachnophobia?' sang Robert Wyatt. Love, for example, is an index of limitation: between the point where I end and you begin there is only interstitial space, limbo. 'The task of reality-acceptance is never completed...' said psychoanalyst D. W. Winnicott. 'No human being is free from the strain of relating inner to outer reality.'

¶ Officers and crew ate and socialized separately. I never saw anyone in the officers' mess, a grim room with a broken shelf holding dog-eared Tom Clancy novels and bootleg DVDs of blockbuster films dubbed into German. The crew were initially distant, but within a week had started to ask why I was travelling with them. I said I was a writer. They asked what sort. I told the white lie that I was writing a science fiction novel. There was a little truth to this; one of those projects I had wanted to do but forever deferred. I felt no desire to talk about art, wanting a break from my working life.

Early April, after my first week on board, the steward discovered on the ship's paperwork that my birthday was shared by one of the other crew. I was invited to a party in the seamen's mess. I watched as they sang karaoke ballads in Tagalog. We drank rum and they talked about how much they missed home. All were married with families to support. I was thirty-two when I took the trip. Still unmarried at thirty-two! You're crazy! What are you doing with your life?

What struck me during the voyage was how quiet these men were. Days would go by in open sea when nobody appeared to speak to anyone else. The atmosphere was monastic. One overcast day in the Andaman Sea, just north of Sumatra, the captain cut the ship's engines for six hours, allowing the crew time to rest and enjoy a barbeque marking the halfway point in their journey from northern Europe to Asia. The *Ital Contessa* – a machine three-and-a-half football pitches long and some forty-storeys high – floated silent in the ocean under the navigational status 'Not Under Command', which according to the International Regulations for Preventing Collisions at Sea signals that a vessel is unable to manoeuvre in the water. Fog hung in the chilly

air, smudging the line between sea and sky. Angelo, the steward, told me that in better weather they once lowered the ship's ladder and swam in the sea. The boat revolved a quiet 360 degrees, nudged slowly by the sea currents. This was not Traven's hellship *Yorikke*. The *Ital Contessa* was a vast, industrial, Trappist retreat in the wilderness.

Some days the only exchanges I'd have would be during meals. Breakfast, lunch and dinner were held at strict times. Entering the dining room, you were expected to make a brief acknowledgement of each person present. Everyone was referred to by their rank, or in my case Mr Fox – nobody besides the steward used Dan. The Chief Engineer, who spent all his time below deck in the gruelling heat of the engine rooms, was a big-boned, aggressive man who rarely acknowledged me, preferring to argue in German with the Captain. Breakfast was eggs and gammon. For lunch was soup or a Filipino stew. Dinner was meat-and-two-veg. I was told that the food on Russian-owned ships was basic, and that on French containers the cooking was excellent. This sounded like national stereotyping, although on my German-owned ship, sausage and sauerkraut were comically plentiful. Chocolate, beer and spirits could be bought with cash directly from the captain – the alcohol only with his approval. Routine reproduced social hierarchies on land but for sanity's sake anchored the small community to a concrete structure in the wilderness of open seas.

If I managed to avoid Michael chiding me for eating soup at sea with the incorrect utensil or whatever trivial infraction irritated him that day, I was left alone. I would wake at six each morning, breakfast, then go up to the bridge and make a note of the coordinates on the ship's chart. The numerical position didn't mean much to me, but I liked the sense that progress was being made,

especially in long stretches of open sea. I'd stare out of the window, share a few words with the officer on watch. After the bridge I'd return to my cabin, make some journal notes – I kept a diary when I was on board, the only writing I would end up producing, and which went missing when I later moved to New York. Late morning I would pass time by taking a walk around the perimeter of the ship, which took around twenty minutes point-to-point. At the vessel's stern, beneath the deck was a lower level open on three sides to the sea. Here I'd watch the crew shoot hoops in a makeshift basketball court squeezed between bulky wheels of rope, and wonder how often balls went overboard.

Narrow gangways took me past stacks of containers. The deck surfaces were painted gun-metal grey, its low gantries and sharp-angled beams covered in yellow and black hazard stripes and warning decals. At night, white-and-green-hued spotlights made the deck look like photographs I'd seen of the Hacienda nightclub in 1980s Manchester, with its nods to factories and other industrial workplaces – a strange connection to make in the middle of the ocean. Small details became significant navigational marks on my circuit – the basketball hoop, the bright orange submarine-like survival craft, an information poster about dumping waste at sea that featured a beautifully drawn graphic of a ship that reminded me of maritime prints by Ian Hamilton Finlay. If I stood next to one specific container on the starboard side of the ship, I could hear a slow, rhythmic THUD... THUD... knocking at the side of the container. According to the ship's manifest inside was someone's car. They'd left the brakes off. These told me I was a certain number of minutes from my cabin, and how much further I'd have to walk to the nose of the vessel.

For exercise I would use a rowing machine in the crew's quarters, and in open seas I would swim in a deep but narrow pool filled with saltwater near the engine room. I had brought a dozen or so books to read. Novels mostly related to the sea or to Shanghai. My choices weren't sophisticated: J. G. Ballard's memoir of childhood in Shanghai, Thor Heyerdahl's *The Kon-Tiki Expedition*, *A Hero of the Island* by Joseph Conrad, Stanislaw Lem's *Solaris*. Attempts, I thought at the time, to help jump myself further into the culture of the sea, whatever that was. Also packed was a Teach Yourself Mandarin course, a beginner's guide to astronomy for the evenings, and two DVDs from my girlfriend – the complete *Monty Python's Flying Circus* and *The Mighty Boosh*. In the afternoons I would read, do an hour of Mandarin, nap. Then dinner at 5 p.m. I'd drink a beer from the ship's tuck box, and be asleep by dark. This would be my routine, with little variation.

I had little contact with the outside world. Karl told me he didn't enjoy thinking about land when he was at sea. 'I liked the isolated little alternative community we were living in. I enjoyed the need for self-reliance. At sea a crew is collectively alone, and that's your whole world. With good people, it's a beautiful thing.'

On *Ital Contessa* there was no internet connection. Occasionally I could pick up stations on a wind-up radio I'd brought with me. Mobile phone signals would only flash up briefly if we sailed into national waters. Travelling the narrow length of the Suez Canal and Red Sea, flanked closely by countries on both sides, if I switched my phone on it would pick up multiple welcome messages. Welcome to Egypt. Welcome to Jordan. Welcome to Sudan. To Saudia Arabia. Eritrea. Yemen. Djibouti. No signal from Somalia. News – just a few

headlines – would arrive twice a week via telex machine. The captain would leave the printout by the coffee machine along with the weather forecast, *Bundesliga* football results, and daily reports from the international Piracy Reporting Centre in Kuala Lumpur, giving the last known locations of ships that had been attacked with RPGs fired from skiffs hunting in the Gulf of Aden.

It was mid-April, and two and a half weeks had passed since leaving Thamesport by the time we reached the narrow Aden passage that squeezed ships from the Red Sea out into the Arabian. That month saw a major spike in pirate attacks from Somalia, taking strategic advantage of the channel. All sea cargo to and from Asia moves through Suez. To avoid the Suez Canal would require travelling all the way around the bottom of Africa. This costs fuel and time which shipping companies aren't prepared to cover, preferring to keep the capital flowing as fast as they can, and deal with a bad situation if one occurs. The Horn of Africa was easy pickings for pirates. The crew of the *Ital Contessa* appeared sanguine about the risk – they were used to the threat – but they were by no means at ease. The ship powered up to top speed, shaved as close to Jordan and as far from Somalia as it could, and went into lockdown for three days. All hands were on watch for unidentified craft. Because of international shipping law at that time, no weapons were allowed on board. The plan was to keep going as fast as the ship could, and if pirates tried to board, the crew would drop empty containers and oil drums on them, or try knocking them into the sea with water cannons. I asked Captain Buchla what would happen if pirates came aboard. An alarm would sound, we would muster in the ship's office, then surrender.

¶ Fear is a by-product of the unknown, but so too is promise. As a student I used to love the smell of oil paint, and the look of white-walled art studios smudged with paint and spoiled with scuff-marks. I was attracted to the atmosphere of black box theatre spaces, even though I could not act. Something was happening in these rooms that pointed to a different way of living about which I wanted to know more.

At the age of twelve, I pestered Mum and Dad into buying me an old church harmonium from a local antiques shop. It was built from heavy wood, with foot pedals to operate the moth-eaten bellows. The ivory keys cracked, half its stops did not work, and it was an absurd contraption for a pre-teen to want. I had a fixation with the wheezy drones it could make. The harmonium made sounds I enjoyed because they somehow signalled 'history', which was freighted with what I then took to be a form of authenticity. Yet they were sufficiently strange enough to entertain ears that were beginning to sense the existence of music beyond the Top 40. There was no room for the organ inside the house, so we put it in the half-finished conservatory I'd been helping Dad to build onto the side of the house, and which was being used for storage. At the time my parents could not afford to have a door knocked through from the kitchen to the patio where the conservatory stood, so Dad decided to simply attach it to the house. To enter you had to leave the house, walk around to the patio, and in through the conservatory door. It was as cold or as hot inside as the weather outdoors.

I was learning the piano at the time, and had started to teach myself the guitar on a small, nylon-stringed acoustic that had belonged to Mark. An electric guitar was out of the question, but I discovered by accident that

a Walkman headphone taped to the body of the guitar and plugged into the microphone socket on my stereo could produce an interesting enough sound. I also discovered that by carefully taping brief snippets from the few records I owned, I could make samples and tape collages though I did not know that these were their names. Hours were spent recording the harmonium, piano, guitar, and the Casio keyboard on which I practiced Pet Shop Boys songs from sheet music. During the school holidays, Dad brought home a VHS video camera from the comprehensive at which he taught. With no experience of filmmaking and with only me as his assistant, he wanted to document a year in the life of Wheatley. I would also make use of the camera to shoot 'music videos' in the garden for my tape collages and cover versions.

I had no language to describe what I was making. It approximated music I heard on the radio, and the records I was starting to take more serious interest in. And in that space of approximation I heard what I wanted to make, not what was there. 'Which do you suppose is the accident?' asks Hippie Girl in Kobo Abe's play *The Man Who Turned into a Stick*. 'When something hits you or when it misses?'

¶ 'Psychoanalysis starts with the story that we are too much for ourselves,' writes Adam Phillips in *Terror and Experts*. When we are confronted by our fears of the unknown we reach out to the expert for help. He observes that

> we are, in a sense, terrorized by an excess of feeling, by an impossibility of desire. And it is terror, of course, that traditionally drives us into the arms of experts; that "Brings the priest and the doctor / In their long coats / Running over the fields," as Philip Larkin writes in his poem "Days."'

The doctor who will tell us what that nasty rash is, the priest who will reassure you of good weather after death. It is exhausting enough to reason with our own feelings and behaviours let alone those of others. Every night our subconscious talks to us in dreams and in hypnagogic in-betweens, describing ourselves to us in ways we scarcely comprehend. (For insomniacs and others tortured by sleeplessness, the racing mind, desperate for oblivion, feels trapped in a circle of Hell rather than in the cool stasis of limbo. I have Restless Legs Syndrome, or Willis-Ekbom Disease, which turns most nights into an exhausting semaphore of twitching limbs. I long for a full night of sleep.) Dream life estranges us from the self we think we understand and choose to present in public. The conscious mind is whispered to nightly by a bad Google Translator. Freud told us that 'the ego is not master in its own house', and our daily behaviours exist somewhere between those backstage prompts of the subconscious and the adult audiences performed to at work and at play.

One of the marvels of the universe is that it makes

amateurs of us all. Educational qualifications only meas-ure the negative space of how much you don't know. Expertise is defined by a professionalized way of doing things and also the expert's outer limits. (The amateur does not have to stick to the rules, because they do not know there even are any rules. But beware the false am-ateur, the one who claims ignorance to dissimulate their motives. Michael Gove, for instance; the profession-al politician who during the Brexit campaign, expertly claimed 'Britain has had enough of experts.') There is a great deal beyond the stockade of this book that I do not know about sailing or limbo's philosophical impli-cations. But ask me anything about editing a magazine of contemporary visual art. Peter Higgs, of Higgs boson fame, is pretty vague about editing magazines, but he's the go-to man for particle physics. Higgs can wax ex-pert about Heisenberg's Uncertainty Principle – he may even know whether Schrödinger's Cat is dead or alive in its box – but can he name all the players in the French squad who won the 2018 World Cup? Neither can I, but perhaps one of the team working the Large Hadron Collider at CERN can rattle off those names without re-course to Google. Unfortunately that same football-mad scientist falls silent when it comes to cocktail-party con-versation about tuning systems in Javanese gamelan music. The composer Steve Reich could tell you a thing or two about gamelan because it's been a major influence on his work, but he couldn't explain the finer points of Hungarian's place in the Finno-Ugric language family.

In his nightmarish novel *Epepe* (also known as *Metropole*), written in 1970 in Communist Hungary, Ferenc Karinthy tells the story of Budai, a professor of linguistics travelling from Budapest to an academic con-ference in Helsinki. When he steps off his flight after a

deep sleep, Budai finds himself in a vast, overpopulated city he does not recognize. The expert cannot speak the mysterious language that governs life here, nor read its alphabet. Managing to get himself a room in a crowded hotel, the polyglot applies himself to deciphering its writing system and speech patterns, but despite his familiarity with the world's major language families, he cannot fathom its mechanics. The meaning and correct pronuncation of words constantly slip away from him, its inconsistencies the only consistency. Unable to even use a telephone to send an S.O.S. to his wife, Budai gradually starts to run out of money to pay for his accomodation and food. An affair with the hotel elevator operator, Epepe – whose name slides each time he hears it between Etete, Ebebe, Djedje, Tyetye and Tete – brings signs of hope, but their ability to communicate is severely constricted. Budai becomes homeless, surviving on the streets. The hotel has kept his passport and visa, and without papers he must subsist on jobs with other undocumented migrants. His only hope out of this cruel city is to somehow find a route to the coast or border – if one exists.

Budai is reduced to the state of a child, as if in a nightmare about being returned to school again. The expert – or adult – is unable to apply what he knows in a meaningful way to anyone outside his own mind. Language cannot salve his loneliness or affirm his existence with others. Budai – a man who has enjoyed comfort and the privileges of status – is forced into involuntary solipsism and turned into an invisible man, like so many others at the mercy of systems that despise them.

¶ At the front of the ship, beyond the container stacks, was a small ladder leading up onto the prow. Noise and vibration from the engines at the back of the ship did not carry here. All that could be heard were waves breaking. I would stand amongst motorized docking gear, ropes, winches and anchors, and stare at the water. Out of boredom some days, awe on others. Flying fish followed the ship for weeks it seemed. Occasionally a school of dolphins would track the boat, and on one occasion a sperm whale. In the Arabian Sea, the water was a flat glass disc, lacquered with an iridescent sheen of petrol residue that spread for miles. Just north of Sumatra we crossed the tail of Cyclone Nargis as it began punching Myanmar. The ship, normally heavily stabilized, rocked port then starboard. I was frightened we would be struck by the lightning which flickered purple in every direction, illuminating the sea like a dying filament bulb. The crew on watch did not seem bothered. I had been unable to sleep that night, and went outside early the following morning to find the entire deck covered with debris that the storm had picked up on its way as it was travelling north. Leaves had dropped everywhere. Insect remains squashed on ladders and slammed against bulkhead doors. For hours a large gull rested so motionless outside the bulkhead door next to my cabin that I thought it was dead. Perched on a wing of the bridge was a colourful, bedraggled-looking bird, which looked as if it had just woken up from the worst night of its life.

When the vessel churned through phosphorescent plankton at night in the South China Sea, the water around the ship looked like a glow-stick sluice. Hundreds of other lights pinpricked the water; Vietnamese and Chinese fishing vessels trespassing the shipping lanes. They crowded the emergency radio frequencies with

K-pop hits and classic '70s rock. Now the watch crew were nervous; the fishing boats could easily be crushed and dragged underwater by the hulking *Ital Contessa* without anyone noticing.

I must have seen hundreds of ships. Those heading east were high in the water, their containers empty. Those sailing west to Europe sunk low in the sea, their cargo weighed heavy with electrical hardware from China, South Korea, Taiwan. Laptops, phones, printers, headphones, speakers, refrigerators, gadgets for the kitchen, tools for home and garden. Inanimate lumps of plastic, metal and wire we carry in our pockets that give the dumb, physical lie to land's Wi-Fi delusions. A few hundred fathoms beneath us were the underwater fibre optic cables that connect the world to the internet. No magic Apple Store, no miraculous Amazon Prime doorstep drop. Just stuff, things, objects, matter; all gliding slowly from one physical location to another. Sailing south down the Suez Canal, on the bank to the right of the ship were towns and cities, orchards and irrigated fields. A few hundred yards to the right was the Sinai Desert; sand, baked all the way to the horizon. Here, wilderness met developed land, nothing met something. A world we take for granted met a world indifferent to us.

Somewhere in the Arabian Sea I spent a sweltering afternoon at the prow of the ship, ocean-mesmerized and overheating without realizing. As I started to feel woozy, a roll-call of pupils I'd been at comprehensive school with began reading itself off in my head. I heard the names of people I had pushed from my mind more than fifteen, twenty years ago. Conversations I'd had years previously replayed themselves. I could smell friends and feel sensations that had long disappeared

from my body.

'Sometimes when you're fatigued at sea it's not un-common to hear things,' Karl told me. 'People crying or voices calling out to you. I've had people wake me up because they thought they heard someone. When I heard voices I'd think: my God did I just sail past a life raft? Was there somebody who sank?' In the 1980s Karl had known the sailor Steven Callahan, whose one-man boat *Napoleon Solo* was smashed to pieces just off the Canary Islands. Callahan survived in an inflatable life raft for seventy-six days, eventually washing up in Guadeloupe dehydrated, starved, covered in sores, unable to stand. 'That was my nightmare right there; stuck, like Steve, in a life raft with ships going by and not seeing you. If you honestly think you hear voices at sea, it'll scare you shitless.'

'The other hallucination that's really common is hearing a train go by.'

¶ The castaway – luckless mariner on enforced retreat – endures in the popular imagination. (At least for those who have never suffered incarceration.) Your ship has been smashed to pieces on the coral reef. Your plane has crashed into the drink. You are alone but the weather is good. Time out on a white sand beach, napping under palm trees, with plentiful fish and coconuts to survive on. Who doesn't look good in a grass skirt? Ruler of your own domain, a crypto-colonial fantasy and an opportunity to model your perfect society. Winnicott said 'it is a joy to be hidden, and disaster not to be found,' and rescue would be preferable for the would-be Robinson Crusoe, but failing that, *Desert Island Discs* assures us of a consolation prize: favourite records, the complete works of Shakespeare and that flotsam piano or set of golf clubs you wished for.

Like the nostalgic longing to live in the burning, ruined, dangerous New York of the 1970s, or vile fantasies of the British Blitz spirit that conveniently omit death, looting and starvation, the castaway life is best enjoyed from a distance. Callahan remembered his ordeal in the memoir *Adrift*: 'My past continues its procession before my mind's eye. There is no freedom to get on with my future. I am not dying and I am not finding salvation. I am in limbo.' Being in limbo is involuntary. It's a state slipped into accidentally, or a condition into which you've been forced. The deserted island makes you do nothing beyond what it takes to survive. It offers a different laziness from the deliberate indolence of Dante's Belacqua, who sits halfway up Mount Purgatory and asks the poet 'what point of going up?' Or Samuel Beckett's Murphy, the 'seedy solipsist' who tries to ritualistically disappear from conventional life by tying himself to a rocking chair, wrapped in scarves. The promise of deserted

island time is to switch off communication, disconnect from technology, money, law, professional and social expectations; perhaps a better life could be lived in the dark. Shortly before he died, Jean-Jacques Rousseau described the solitary life as a 'feeling of existence stripped of all other affectations is in itself a precious feeling of contentment and peace'.

The castaway tale is the cousin of science fiction's 'last man' narratives, in which one person is stuck alone on Earth: Mary Shelley's pioneering story *The Last Man*, M. P. Shiel's *The Purple Cloud*, Richard Matheson's *I Am Legend*, *The Wall* by Marlen Haushofer. But generations of British schoolchildren taught William Golding's *Lord of the Flies* are instructed not to fantasize too much about starting over. A society of young boys, stranded on a deserted island, reconstructs itself with ugly, brutish violence as their middle-class privilege congeals into a power struggle. Best stay at home, get a job, and don't think too much about the fragility of community, unless you wish to die like the intellectual Piggy, who thought too much about such problems and paid for his compassion with his life. For the naval officer Christopher Martin, washed up on a desolate rock in the North Atlantic after his ship is torpedoed in Golding's *Pincher Martin*, the isolation requires him to draw on all his instincts to remain sane. Martin shifts his sense of scale to the minutiae of the rock, giving small rivulets, crevices and outcrops the names of streets and pubs back on land, gathering weeds and limpets from 'the High Street' to eat at 'The Red Lion'. But Martin is already dead. The ordeal on the rock is merely data recounted from a consciousness surviving in another dimension – a purgatory or limbo.

For the community that retreats from the world to a

dimension of their own making, isolation provides freedom. Idealistic communards in the 1960s and '70s took the opportunity to rethink society from the ground up. Retreat from a world built by greedy old men, the kind of world that had led Buckley to stick a shark in Heine's roof. In the US were communes based on back-to-the-land beliefs: The Farm in Tennessee, and Tolstoy Farm in Washington state, for instance. Other groups organized themselves around scientific principles such as Twin Oaks in Virginia, which took inspiration from the novel *Walden Two*, written by the psychologist B. F. Skinner and which placed its emphasis on the idea that it is only environmental factors that shape behaviour. The era saw all-women communities grow, gay communes and collectives organized around political causes and religious beliefs. Some failed simply because the energy needed to sustain an independent community became too draining, others because of problems with drugs, crime, or – as in the case of the MOVE black liberation community, bombed by the Philadelphia police – violent harassment from the authorities. As any student of cults can tell you, isolation also affords the freedom to abuse and control. Liberty for one comes at the expense of liberty for others.

In his acid-freaked interpolation of Dante, *Jimbo's Inferno*, the artist Gary Panter depicts a group of sullen hippies mooching around listening to the musician Tiny Tim, as Bruce Lee bosses the crowd to keep moving along. They are in limbo – a vast, empty plane outside the Gates of Hell, with a conical-shaped Mount Purgatory visible on the distant horizon. Here, the 1960s counterculture, born on the fringes of the mainstream, is kept at the margins for failing to deliver on its promises of peace, love and revolution in consciousness.

Artists might make themselves castaways because of burnout, because they may only have one book or body of work they feel that they can deliver before disappearing into another life. Or it could be fatigue, disillusionment, even disgust with the industry in which they work. Artist Lee Lozano walked away from the art world altogether. Her *Dropout Piece*, begun in 1970, constituted her withdrawal. 'DROPOUT PIECE IS THE HARDEST WORK I HAVE EVER DONE' wrote Lozano in a notebook from April 1970. 'IT INVOLVED DESTRUCTION OF (OR AT LEAST COMPLETE UNDERSTANDING OF) POWERFUL EMOTIONAL HABITS.'

In his cabin on Walden Pond, Henri David Thoreau kept three chairs: 'one for solitude, two for friendship, three for society'. Isolation must be tempered with company. In Christian monastic orders, the anchorite or individual who chooses the eremitic life for reasons of prayer and solitude, must maintain some contact with their community, and return after a specified period of time alone. (In a letter to Robert Lowell from 1948, Elizabeth Bishop wrote: 'I have digested all the *New York Times* and some pretty awful clam-chowder I made for myself, I don't feel the slightest bit literary, just stupid. Or maybe it's just too much solitude.') Even Thoreau eventually needed more than the silence of Walden:

> I left the woods for as good a reason as I went there. Perhaps it seemed to me that I had several more lives to live, and could not spare any more time for that one. It is remarkable how easily and insensibly we fall into a particular route, and make a beaten track for ourselves. ... How worn and dusty, then, must be the highways of the world, how deep the ruts of tradition and conformity! I did

not wish to take a cabin passage, but rather to go before the mast and on the deck of the world, for there I could best see the moonlight amid the mountains. I do not wish to go below now.

¶ I find it easier to imagine what home means to Karl now than I did before living outside Britain. After a decade in New York, when I return to London, I feel as if I am a ghost. Friends have moved on. New young people have come to replace the old young people I used to run with. Familiar shops and cafes have gone under. Buildings have been knocked down and the new ones disorient me because I can't navigate by them in the same ways that I used to, I can't use them like the shark and Karl's rocket. 'Do you remember the good old days before the ghost town? / We danced and sang as the music played in any boomtown.' But this is no Specials' *Ghost Town*, no Imber. It's alive, changing. I mourn the past with an old, outdated emotional gazetteer as a guide, without acknowledging the extent to which I carry with me new habits of thought, and conduct conversations in my head with friends overseas. I am not of the same dimension. My London is a childhood visit in 1989, an adolescent trip in '93, and a Rotherhithe warehouse in 2002. I visit this London cast from the experience of John Giorno's Bowery time machine of 1964, 1979 and 2014 and of Imber in '43 and '03.

Home is where you presently live, your friends, job, the culture you move inside. And if you have lived overseas, home is the bone-deep sensation – pleasant or not – that you feel on returning to the country you grew up in. The scale of the land, shape of trees, quality of light. The look of buses and type of music heard booming from passing cars, the size of milk cartons and the ability you have to hear nuanced social codes compressed into a single gesture or idiomatic grunt. For those who choose to move country, this can be a bittersweet experience, or even one that reinforces their decision. For the forced exile, they have no option to return, hanging onto

a narrative promise of one day going home.

Close to the Knives, artist David Wojnarowicz's harrowing memoir of life during the 1980s AIDS crisis, contains the observation: 'It is no accident that every guidebook in every conceivable language contains the translated phrase: DO YOU HAVE A ROOM WITH A BETTER VIEW?' No person can escape the chore of reconciling inner life with external reality. See also: desire. The Other Side where the grass is spray-painted a more attractive shade of green. And so we wait for the correct papers to be delivered that will provide exit from limbo. We wait to be understood, wait to know ourselves more clearly, wait to meet the right person, wait for Godot, wait for Guffman, wait for a better idea, wait for a new opportunity. For a room doesn't look out onto a dirty concrete airshaft. A place where you and Thoreau might 'best see the moonlight amid the mountains.' Where you do not have to stay below deck.

I asked Karl why he left home. 'If I'd have stayed in Wheatley and gotten married, worked as a mechanic at the garage, that's all there would have been, and that's why I wanted out. Seeing other people in the village doing exactly what their parents did. Thursday night down at the social club or the King & Queen pub. You might get a new car at some point, or a raise, little things might change, but nothing big does. At that point there is an end and you can see you've reached it. That's your life. That wasn't for me.'

Karl's departure and the Headingon Shark's arrival seemed linked. One swapped out for the other. If one day the shark were to be removed, I would be sad to see it go, but I would not mind on the chance that it's disappearance might, through some form of sympathetic magic, bring my brother home again. The shark was

a placeholder, a reminder that the life Karl had opted for was always an option if the inland routine bit hard. Karl–One, Shark–Nil. 'Change is good,' said Karl. 'That's what catches most people out. It's not that I'm not afraid of change, I'm just less afraid of it than most. There's never an end.' Every goodbye ain't gone.

¶ It wasn't until four weeks into the trip that I was able to step off the ship. At Tanjung Pelepas, a high-tech port at the mouth of the Pulai River in Malaysia, we picked up two other passengers: Kevin and Shirley, an Australian couple spending their retirement travelling by container ship. They were on their way to visit their son and daughter-in-law in Hong Kong. Both were ex-military; Kev had been a sports instructor, Shirley had worked in intelligence. He was garrulous, wore shorts that were a little too short and jogged the length of the ship each day. She was quieter, originally born in Britain, a 'ten-pound Pom' who arrived in Australia under the Assisted Passage Migration Scheme in the 1950s. After too many sea-hypnotisms and enough of Michael's explanations about the organization of container manifests, wondering to myself what ghastly crime he was running from back in Germany, I was grateful for their company. Due to a misunderstanding that I could never quite correct they'd become convinced I was a novelist working on a thriller, and kept suggesting plot lines for the book I was supposedly writing. Kev wanted it to be an erotic adventure, at which Shirley rolled her eyes and I felt uncomfortable. Michael developed an intense dislike for them from the instant they called him 'Mike.' Over breakfast as we closed in on Yangshan, his control snapped, and he screamed at Shirley for 'talking too much'. She was the only woman onboard, which she had told me did not bother her. Shirley presented as tough, but Michael's outburst brought her to tears. Kev threatened to punch him. Michael was reprimanded by the captain, and was to sit alone at meals for the remainder of the trip, refusing to speak.

It was foggy and wet when we arrived at Yangshan. Grey water faded into pure white low cloud, like the

edge of a drawing in which the picture simply gives way to blank paper. The deep-sea terminal was built on landfill, grafted onto a small archipelago south of Shanghai in the Hangzhou Bay, to take ships that could not enter Shanghai's shallower waters. It is tied to the mainland by the thirty-mile-long Donghai Bridge, a structure that curves and snakes across the water to minimize typhoon wind damage. Arrangement had been made through the captain that I was to pay a Chinese shipping agent two hundred dollars in cash to drive me to the city. Around 7 a.m., Captain Buchla, Chief Officer Walther, Angelo the steward and one of the younger seamen whom I had chatted to regularly came say goodbye. Kev turned up to shake my hand and wish me luck with the thriller; Shirley sent her best but was too upset from the outburst at breakfast to leave her cabin. I had tried to say goodbye to Michael but he would not speak. The Chief Officer presented me with a certificate to say I'd done six weeks with them on the ship. Someone made a dry joke about being stuck with Michael until Hong Kong. We liked having you, the captain told me. You didn't get in the way.

I left the *Ital Contessa* and was taken to the immigration checkpoint at the edge of the island. Shipping agents and crew members from other vessels brought in piles of twenty or thirty crew passports at a time for processing. Before leaving the UK I'd been instructed to get a double-entry visa into China because we were making two stops. The first was Ningbo, an allegedly Triad-run port where the thick yellow air tasted toxic. Here I'd been driven from the port to a local immigration office in the nearby town, where my passport was stamped. On arrival at Yangshan, I assumed I would go through the same process, then head to Shanghai.

One of the older members of the *Ital Contessa* crew on my ship had suffered a minor coronary the day before, and the shipping agent was to take him to a hospital in Shanghai for a check-up. He waited in the car as the agent – a patient, quiet man in his sixties who acted as my translator – took me through immigration. Looking at my passport, the officer on duty asked why I was staying in China. I told him I was on holiday, but had taken an unusual route to get here. Other officials were called over. I was instructed to wait. Two hours passed. The agent told me stories about forced labour in his youth during the Cultural Revolution. He urged me to try to see the flowers in Guangzhou during the Spring Festival, insisting they were the most beautiful spectacle he had seen. Police arrived – a man and a woman. Why are you leaving the ship here? they wanted to know. The stamp in your passport says you're a merchant seaman. I tried to explain that I was a tourist, that this must have been an administrative mistake in Ningbo. I was taken to a windowless room containing a desk and chair, and locked inside.

Over the course of three or four hours, every fifteen to twenty minutes, the two officers would ask me questions about my passport. Why did I have a Turkish visa stamp? How much money did I have with me? Where was I staying in Shanghai? Was I meeting anyone? What is her name? Why did you arrive in China by ship? They would then leave, and return with the same questions. Where was I staying in Shanghai? Why did I have a Turkish visa stamp? Why did you arrive in China by ship? How much money did I have with me? Was I meeting anyone? What is her name? Finally they returned my passport with a new stamp and no explanation. I walked to the car. The agent drily said, 'Welcome

to China.'

A day of container ship travel is equivalent to an hour's distance on a plane. As the *Ital Contessa* moved eastwards on the Mediterranean leg, the onboard clocks would go forward by one hour every day or two. I experienced 'shiplag' – a slow-motion fatigue that brought exhaustion in incremental weights. Karl had told me that time would become 'mushy' during a voyage. My mush extended beyond Shanghai, and came with me back to Britain. I packed it in my suitcase when I moved to New York a year later. I had no sense of achievement once I reached China, only the sensation of having paused myself and stepped into a parallel world. ('I just left myself', goes Terry Allen's old country and western song.) For the first few months I could not think of anything interesting to say about my trip. I could speak only in details: the car destroying itself in the container, heatstroke visitations from old classmates, Kev's uncomfortably short shorts. The ocean generated then reabsorbed the experience for me. The memory was stored on the water and refused to land.

¶ 'I would often be between jobs, with no money, living on people's couches or boats,' Karl said.

> And there's the temptation to just go home – all I need to do is get back to England and I'll be fine. But then I got to the point where I felt comfortable just being a traveller, and not having a home. Hopping on a boat and going somewhere with some people you've not met before, there's trepidation, excitement, and a whole lot of unknown. After a while you know there are going to be rewards either during or after the process, in the journey itself or where you end up. Life's not as finite, it doesn't come to you as quickly when it's so far over the horizon. There's never an end point.

Karl's life has echoed Thoreau's line that 'our horizon is never quite at our elbows.' True for the woods of Walden Pond, and also at sea where its hallucinatory truth is clearest. I stood on the bow of the *Ital Contessa*, one humid afternoon in the middle of the Indian Ocean south of Sri Lanka. With no clouds, no land masses, no objects on the surface of the water by which to judge speed or distance I experienced a vivid sensation that the vessel was not moving. If I stuck my head down through the large hawseholes at the prow, I could see that the ship was still pushing waves. If I looked up, the boat appeared stationary again. Staring at the sea long enough for the focus of my eyes to stone-skim across distances, the water began to look as if it had taken the form of a shimmering liquid wall. I stopped perceiving the ocean as an horizontal expanse of water and understood it to be a vertical bank of brine, miles deep, topping out with the horizon, where one blue slopped into another in the heat haze. The effect was like being a specimen in the middle of a vast, pelagic petri-dish. In limbo.

Sources:

Books, essays and plays

Edward Abbey, *Beyond the Wall: Essays from the Outside* (1984)

Kobo Abe, *The Man Who Turned into a Stick* (1961)

Joan Acocella, 'Blocked: Why Do Writers Stop Writing?',
The New Yorker (2004)

Dante Alighieri, *The Divine Comedy* (c. 1320)

Emily Apter, *Unexceptional Politics: On Obstruction, Impasse and the Impolitic*
(2017)

Thomas Aquinas, *Selected Writings* (1998)

James Baldwin, 'Every Good-bye Ain't Gone' (1977) in *Collected Essays*
(1998)

J.G Ballard, *Concrete Island* (1974)

Samuel Beckett, *Happy Days* (1961), *Murphy* (1938), *Waiting for Godot* (1953)

Harold Bloom, 'Paradise Found, Limbo Lost', *The New York Times* (1
January 2006)

Edward Kamau Brathwaite, *Islands* (1969)

Andre Breton, *Nadja* (1928)

Svetlana Boym, *The Future of Nostalgia* (2001)

Steven Callahan, *Adrift: 76 Days Lost at Sea* (1986)

Paul Clinton, 'One Man Protest', *frieze* (March 2017)

Mihaly Csikszentmihalyi, *Flow: The Psychology of Optimal Experience* (1990)

Stephanie DeGooyer, Alastair Hunt, Lida Maxwell, Samuel Moyn,
Astra Taylor, *The Right to Have Rights* (2018)

Brian Dillon, *In the Dark Room* (2005)

Guy Endore, *The Man from Limbo* (1930)

Richard Fairfield, *The Modern Utopian: Alternative Communities of the '60s
and '70s* (2010)

Mark Fisher, *The Weird and The Eerie* (2016)

Alice W. Flaherty, *The Midnight Disease: The Drive to Write, Writer's Block
and the Creative Brain* (2004)

William Golding, *Lord of the Flies* (1954), *Pincher Martin* (1956)

Witold Gombrowicz, *Ferdydurke* (1961)

Henry Green, *Party Going* (1939)

Jonathan Griffin, *On Fire* (2016)

Lynsey Hanley, *Respectable: The Experience of Class* (2016)

Wilson Harris, *History, Fable and Myth in the Caribbean and Guianas* (1970)

Stephanie Jenkins, 'The Headington Shark', headington.org.uk/shark

B.S. Johnson, *Trawl* (1966)

Franz Kafka, *The Castle* (1926), *The Trial* (1925)

Ferenc Karinthy, *Metropole* (1970)

Wayne Koestenbaum, *Humiliation* (2011)

Steven Kotler and Jamie Wheal, *Stealing Fire: How Silicon Valley, the Navy SEALs, and Maverick Scientists Are Revolutionizing the Way We Live and Work* (2017)

Harriet Lane, 'Don't Look Back in Imber', *The Observer* (10 August 2003)

Zachary Leader, *Writer's Block* (1991)

Jonathan Lethem, *Amnesia Moon* (1995)

Tom Lutz, *Doing Nothing: A History of Loafers, Loungers, Slackers and Bums in America* (2006)

John W. MacDonald, *The Man from Limbo* (1953)

China Mieville, *The Last Days of New Paris* (2016)

Marion Milner, *On Not Being Able to Paint* (1950)

John Milton, *Paradise Lost* (1667)

Brian O'Doherty, *Inside the White Cube: The Ideology of the Gallery Space* (1999)

Tillie Olsen, *Silences* (1978)

Susan Owens, *The Ghost: A Cultural History* (2017)

Gary Panter, *Jimbo's Inferno* (2006), *Jimbo in Purgatory* (2004), *Songs of Paradise* (2017)

Adam Phillips, *Terrors and Experts* (1995)

Nick Pisa, 'The Pope Ends State of Limbo After 800 Years', *The Telegraph* (27 April 2007)

Dick Pountain and David Robbins, *Cool Rules: Anatomy of an Attitude* (2000)

Phillip Pullella, 'Catholic Church Buries Limbo after Centuries', reuters. com, (20 April 2007)

Claudia Rankine, 'Don't Let Me Be Lonely: An American Lyric' (2004)

Nicholas Ridout, *Stage Fright, Animals and Other Theatrical Problems* (2006)

Jean-Jacques Rousseau, *Reveries of the Solitary Walker* (1778)

Nick Salvato, *Obstruction* (2016)

Rex Sawyer, *Little Imber on the Down* (2001)

Elizabeth Schambelan, 'In the Fascist Weight Room', *Bookforum* (2018)

Mary Shelley, *Frankenstein* (1817)

Mary Shelley, *The Last Man* (1826)

Amy Sillman and Gregg Bordowitz, *Between Artists* (2007)

Rebecca Solnit, *A Field Guide to Getting Lost* (2005)

Mihai I. Spariosu, 'Exile and Utopia as Liminal Play' (1997) in *Philosophical Perspectives on Play*, Ed. Malcolm MacLean, Wendy Russell, Emily Ryall (2015)

Klaus Theweleit, *Male Fantasies* (1977)

Henry David Thoreau, *Walden* (1854)

B. Traven, *The Death Ship* (1926)

John Waters, 'Leslie' (2009) in *Role Models* (2010)

Evelyn Waugh, *The Ordeal of Gilbert Pinfold* (1957)

Carolyn Williams, 'The Gutter Effect in Eve Kosofsky Sedgwick's *A Dialogue on Love*' in *Graphic Subjects: Critical Essays on Autobiography and Graphic Novels* (2011)

David Wojnarowicz, *Close to the Knives* (1991)

Virginia Woolf, *A Room of One's Own* (1929)

Film and television

A Matter of Life and Death (Michael Powell and Emeric Pressburger, 1946)

Adaptation (Spike Jonze, 2002)

After Life (Hirokazu Kore-eda, 1998)

Being John Malkovich (Spike Jonze, 1999)

Franz Kafka's It's a Wonderful Life (Peter Capaldi, 1993)

Get Out (Jordan Peele, 2017)

Giantbum (Nathaniel Mellors, 2009)

Groundhog Day (Harold Ramis, 1993)

Inception (Christopher Nolan, 2010)

Matrix Revolutions (Lana and Lily Wachowski, 2003)

The Raft (Marcus Lindeen, 2018)

Stalker (Andrei Tarkovsky, 1979)

The Stone Tape (Peter Sasdy, 1972)

Stranger Things (TV series, 2016–ongoing)

The Twilight Zone (TV series, 1959–64 and 1985–89)

Twin Peaks (TV series, 1990–2017)

The Unfinished Conversation (John Akomfrah, 2012)

Music

Terry Allen, 'I Just Left Myself' (1979)

Chubby Checker, 'Limbo Rock' (1961)

Roz Croney, *How Low Can You Go?* (1963)

Brian Eno, 'By This River' (1977)

Ray Godfrey, 'I Gotta Get Away (From My Own Self)' (1970)

Noel Harrison, 'Windmills of Your Mind' (1968)

Japan, 'Ghosts' (1981)

Sun Ra and His Astro Infinity Arkestra, 'Somebody Else's World' (1971)

Sun Ra and His Myth Science Arkestra, *When Sun Comes Out* (1963)

The Specials, 'Ghost Town' (1981)

The Velvet Underground, 'Stephanie Says' (1968)

Robert Wyatt, 'Free Will and Testament' (1997)

Acknowledgements

I owe Jacques Testard of Fitzcarraldo Editions a big debt of thanks for his patience, keen editorial advice and continued support. Thank you, again, to Ray O'Meara for his elegant book design and to Nicci Praça for spreading the word.

Sections of *Limbo* expand on passages that first appeared in *frieze* magazine – 'Village People' (October 2003), 'Known Unknowns' (March 2014), and 'Fatal Frame' (February 2018) – and an interview conducted by Mark Fisher, published as 'Silent Running' in the book *When Site Lost the Plot*, edited by Robin Mackay (2015).

This book would not have emerged without conversations, both big and small, with Mark Beasley, Andrianna Campbell, Paul Clinton, Joe Cohen, Andy Cooke, Anthony Discenza, Abbey Dubin, the late and greatly missed Mark Fisher, Julian Hoeber, Andrew Hultkrans, Jennifer Kabat, Prem Krishnamurthy, Alix Lambert, Claire Lehmann, David Levine, Jessica Loudis, Nathaniel Mellors, John Menick, Olivia Mole, Gary Panter, George Pendle, Michael Portnoy, Clementine Seely, Astra Taylor, Marcus Werner Hed, Chris Wiley and Johnny Vivash. Thank you. Cheers to Abraham Adams for the themed ales in Vermont.

Love and gratitude to David Birkin, Stephanie DeGooyer, Emily De Groot, Molly McIver, Sierra Pettengill, Sukhdev Sandhu and especially Sarah Resnick. I'd still be in limbo otherwise. Deepest goes to my family: John, Glenys, Mark, Ellen, Osian, and in this episode, guest star Karl, for everything.

Fitzcarraldo Editions
8-12 Creekside
London, SE8 3DX
United Kingdom

ISBN 978-1-910695-80-7

Design by Ray O'Meara
Typeset in Fitzcarraldo
Printed and bound by TJ International

fitzcarraldoeditions.com

Fitzcarraldo Editions